Andrea Mantegna

THE ADORATION
OF THE MAGI

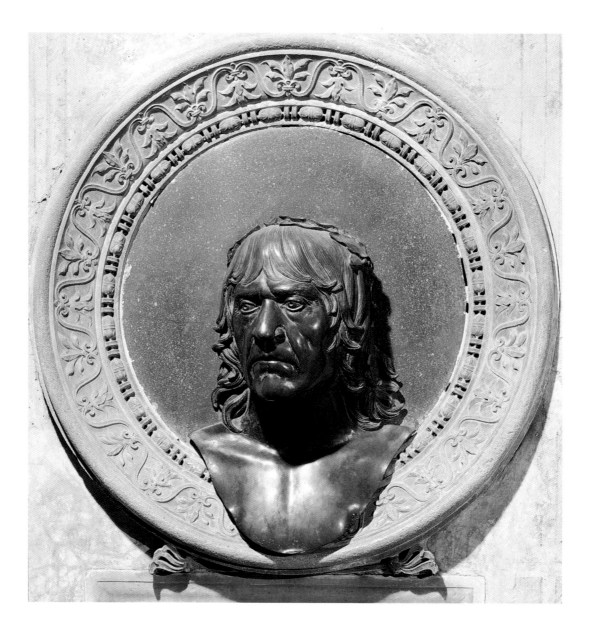

Andrea Mantegna

The Adoration
of the Magi

Dawson W. Carr

**GETTY MUSEUM
STUDIES ON ART**

Los Angeles

Christopher Hudson, *Publisher*
Mark Greenberg, *Managing Editor*

Mollie Holtman, *Editor*
Suzanne Watson Petralli, *Production Coordinator*
Jeffrey Cohen, *Designer*
Charles V. Passela, Lou Meluso, Ellen Rosenbery,
Jack Ross, *Photographers*

© 1997 The J. Paul Getty Museum
1200 Getty Center Drive, Suite 1000
Los Angeles, California 90049-1687

Library of Congress
Cataloging-in-Publication Data

Carr, Dawson W. (Dawson William), 1951–
 Andrea Mantegna :
 The Adoration of the Magi /
 Dawson W. Carr
 p. cm. — (Getty Museum studies on art)
 Includes bibliographical references.
 ISBN 0-89236-287-1
 1. Mantegna, Andrea, 1431–1506. Adoration of
 the Magi. 2. Magi — Art. 3. Mantegna, Andrea,
 1431–1506 — Criticism and interpretation.
 4. J. Paul Getty Museum. I. Title. II. Series.
 ND623.M3A62 1997
 759.5 — dc21 97-17639
 CIP

Cover:

Andrea Mantegna (Italian, circa 1430–1506).
The Adoration of the Magi, circa 1500 [detail].
Distemper on linen, 48.5 × 65.6 cm (19⅛ ×
25⅞ in.). Los Angeles, J. Paul Getty Museum
(85.PA.417).

Frontispiece:

Andrea Mantegna(?), Funerary Monument of
Andrea Mantegna, installed by 1516. Bronze on
porphyry framed by Istrian stone. Mantua,
Church of Sant'Andrea, Chapel of San Gio-
vanni Battista (Mantegna's memorial chapel).

All works are reproduced (and photographs
provided) courtesy of the owners, unless other-
wise indicated.

Typography by G&S Typesetters, Inc.
Austin, Texas
Printed in Hong Kong by Imago

CONTENTS

Final page folds out,
providing a reference color plate of
The Adoration of the Magi

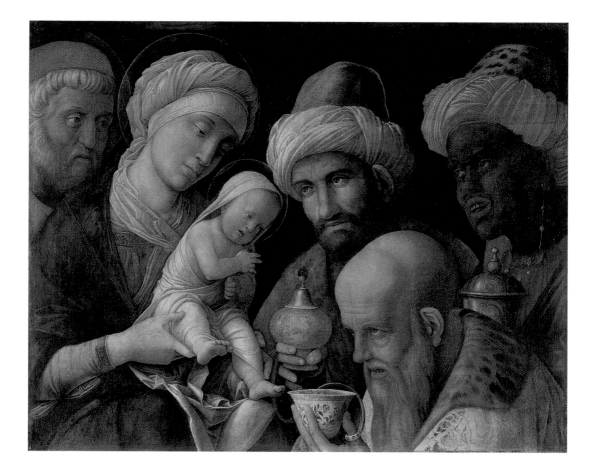

INTRODUCTION

In *The Adoration of the Magi* [FIGURE 1 and FOLDOUT] Mantegna arrests our attention with a convergence of heads, tightly grouped within the confines of the fine linen canvas. Isolated against a dark background and pushed up close to the surface of the painting, the scene focuses on the one complete human form, the baby. Even if we knew nothing of the subject, even if Mantegna had not included haloes, we would sense that this is a divine child from the awed expressions of the three men at right. We begin to grasp that we are privileged spectators at a momentous event.

As the painting is based on one of the best loved stories of Christianity, many readers of this book, regardless of personal faith, would recognize it if only from depictions on Christmas cards. The Adoration of the Magi is one of two biblical accounts of the birth of Jesus Christ and his recognition as the Son of God. As such, it became one of the most popular subjects in European art and is often used to signify the Incarnation, or God's taking on of human form. It marks the beginning of the process of Christian salvation and also serves as a prototype of Christian worship.

The simple Bible story can be quickly recounted. The "Wise Men," as "magi" is most conveniently translated into English, note an astrological phenomenon that they interpret as heralding the birth of the Jewish Messiah, prompting their journey from "the East" to pay homage to the newborn "King of the Jews." In Jerusalem, they seek guidance from Herod the Great about where to look for the Child, causing the king to fear usurpation. Nonetheless, he informs them that the Scriptures foretell Bethlehem as the site of the Messiah's birth. When the Magi set out again, the star guides them to the Child and his mother. Recognizing the baby as God incarnate, they fall down and worship him, presenting rich gifts as tokens of their devotion.

Mantegna portrays the event at its expressive and physical climax. On one side is the Holy Family. The baby Jesus is held up for the Magi to see by his mother Mary. Her husband Joseph stands behind, regarding the exotic strangers.

Figure 1
Andrea Mantegna
(Italian, circa 1430–
1506). *The Adoration of
the Magi*, circa 1500.
Distemper on linen, 48.5
× 65.6 cm (19⅛ ×
25⅞ in.). Los Angeles,
J. Paul Getty Museum
(85.PA.417).

While the Magi were not named in the biblical account, by the eighth century they were often assigned names, usually corresponding with their ages. Here, the eldest, Melchior, kneels first and offers his gift to Jesus as the middle-aged Balthasar and the young Caspar crowd in for a better view. All three are transfixed with wonder and awe.

Mantegna thrusts the viewer into the scene with his use of the close-up, centuries before it became the familiar technique of motion pictures. In contrast with the pageantry and exoticism seen in most representations of this subject, this is a composition in which nothing could be spared without loss. There is no redundancy, no triviality. Here we are compelled to regard and share in a very human response to an encounter with God.

We do not know the exact function the painting served or the identity of its first owner. The scale and intimacy of the image strongly suggest that it was intended for a private context rather than a church or other public setting. It might equally have been displayed on the altar of a small private chapel or on the wall of a room. Whatever the circumstances of its original exhibition, the character of the work indicates that it was meant to involve the eyes and mind of the individual believer. While *The Adoration of the Magi* was doubtlessly conceived to inspire devotion, it was also painted long after Mantegna had achieved fame, so the first owner would have greatly prized it as an example of his art.

Indeed, the close-up focus beckons us not only to ponder the significance of the event but also to marvel at Mantegna's legendary skill in rendering form. Everything in the composition is defined with a sharp-edged precision that is uniquely his. In spite of the narrow depth of the painting, the figures are quite plastic, highlighted by a strong light cast from the upper left. The artist revels in the differentiation of textures, from the crisp folds of the turbans to fur, stone, and flesh. The treatment of hair and other minutiae borders on the compulsive, but Mantegna's attention to detail is always balanced with an impeccable sense of overall unity.

THE MAKING OF THE PAINTING

Mantegna created *The Adoration of the Magi* with a type of paint that complements the precision and crispness of his style. It is made by mixing finely ground

pigments (the actual particles of colored matter) with animal glue, which binds it together and fixes it to the linen on which it is applied. This binder, or medium, is called "distemper" or "glue size" in English, and it was commonly found in the artist's studio, where it was also used to seal canvases before painting.[1] Distemper paintings are little known even to historians because few survive in good condition. The medium is quite demanding and, perhaps for this reason, never attained the popularity of the two most familiar media used by European painters: egg tempera, which employs the strength and richness of yolks as a binder, or the newer drying oils, with the renowned transparency and workability increasingly sought by younger painters of Mantegna's era (and still favored by many today).

While Mantegna used egg tempera throughout his career, he came to favor distemper for many of his devotional paintings, apparently for its distinctive handling and exquisite optical qualities. Distemper was almost invariably applied to fine linen that was minimally prepared, often with just a light coat of gesso, as Mantegna used here. Quite different from tempera, whose thick consistency and quick drying time require short brushstrokes that resemble broken hatching, distemper can easily cover broad areas, often in a single, thin application, because pigments appear opaque in the medium.

Distemper paint remains water soluble even after drying, promoting the blending of tones for transitions of great subtlety, as can be seen in the extraordinary modeling of forms in *The Adoration of the Magi*. However, the medium's soluble nature requires great care and lightness of touch when paint is to be applied over existing paint without blending, as in the rendering of facial features, hair, and patterns on stone and fabric. In less skillful hands, the paint becomes muddied, especially when a light color is placed over a dark one. The solubility of distemper paint also means that varnish should never be applied over it, as we shall soon see.

In distemper, the technique of modeling a figure was generally the same as with fresco and tempera: the colors were applied in a systematic sequence from dark to light, unlike oil, where successive layers of transparent glazes were built up from light to dark. However, a detail of the headdress of the Madonna [FIGURE 2] demonstrates that Mantegna laid a relatively uniform layer of ochre as a middle tone and then modeled both up and down. For the highlights, he added yellow and white to the basic ochre, and for the darkest spots, he

created a kind of "glaze," presumably by adding black to the color and then suspending it thinly in medium, in spite of distemper's usual opacity. As anyone who has worked in this medium will attest, Mantegn'a blending is impressive in its sure, unmuddied quality.

A well-preserved distemper painting possesses intense visual power. Although its pigments are identical to those used in tempera and oil, the glue medium is particularly celebrated for allowing colors to appear their most brilliant. Even more than egg tempera, it is a medium of great luminosity. This translates into exceptionally clear and beautiful colors in good light, but it also means that a distemper painting is extraordinarily legible and effective in low light, like that of a chapel. By contrast, the oil medium requires abundant light to attain its full transparency and depth. As many of Mantegna's patrons lived in dark, fortified castles, this characteristic of distemper was surely an advantage. Another beneficial optical quality of distemper is its matte surface, which does not produce glare like varnish over oil or tempera paintings. In Mantegna's well-preserved distemper paintings the surface quality more closely resembles the flat brilliance of fresco, the venerable wall painting medium of the ancients, which was surely no accident.

Mantegna enlivened the bright distemper colors with shell gold, a powdered form of the precious metal that was customarily mixed in a seashell with

Figure 2
Andrea Mantegna.
The Adoration of the Magi
[detail].

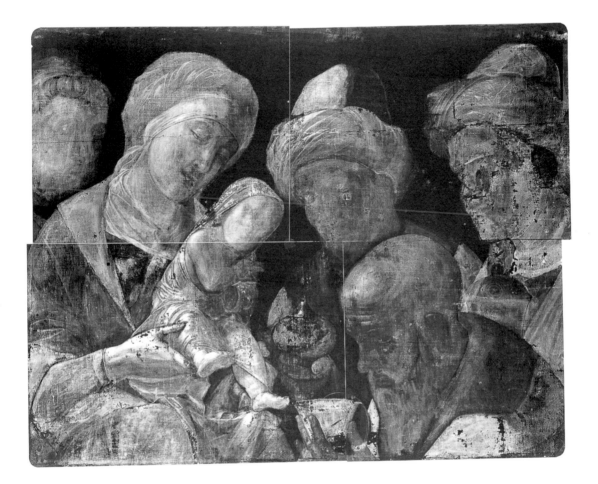

Figure 3
Andrea Mantegna.
The Adoration of the Magi.
X-radiograph.

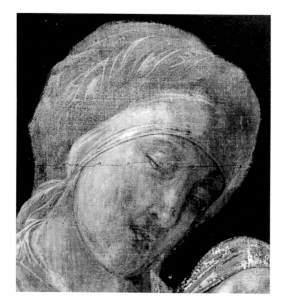 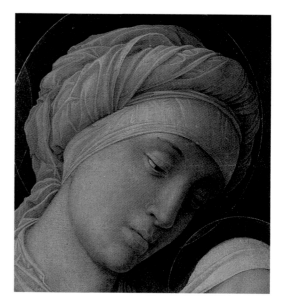

Figure 4
Andrea Mantegna.
The Adoration of the Magi
X-radiograph [detail].

Figure 5
Andrea Mantegna.
The Adoration of the Magi
[detail].

a binder such as gum arabic. He uses it to define not only the coins and the jewelry but also the shot pattern and trim of the Madonna's bodice, as well as the now-faint brocade design on the hat of the central magus. The haloes were created by scumbling, or lightly dragging the gold across the surface with a brush so that just a veil is left behind.

Mantegna's great sureness in the application of paint is particularly evident in the X-radiograph of *The Adoration of the Magi* [FIGURE 3], which lets us see things the artist painted over as well as what is visible on the surface; thus we can detect the artist's changes of mind. But we will find no major alterations in Mantegna's composition. He must have planned the image so thoroughly in drawings that he needed only to refine details during the creation of the painting. Unfortunately, no preparatory sketches are known for this work. In fact, so few exist for his paintings that we must assume the artist systematically destroyed them after they had served their purpose.

Perhaps the most noticeable change or refinement made by Mantegna in the process of painting is the deletion of the finger that once extended beyond the porcelain cup in the foreground; he painted this out after he realized its awkwardness. The blurry quality of the head and proper right foot of the Christ Child indicate that the artist made some slight changes as he probed for a pre-

cise expression or position in space. Likewise, the heads of Joseph and Mary show some rethinking, as does the Madonna's left index finger.

A comparison of the X-radiograph and finished painting [FIGURES 4–5] shows how Mantegna subtly refined the head of Mary, particularly its elegant, undulating contours. The X-radiograph reveals that the form of her headdress was first laid down broadly; then its angular silhouette was developed. The artist also reduced the lower edge of the Madonna's jaw and painted out the cloth of the headdress along the inner side of her face, initially intended to extend much farther down. By doing this, Mantegna concentrates on the exquisite shape of her cheekbone and provides an open field for the intersection of the two haloes.

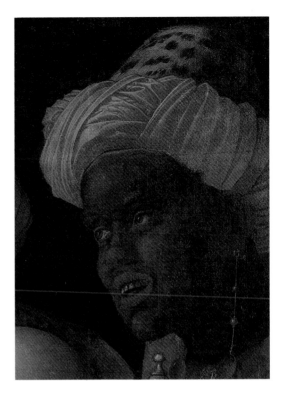

Figure 6
Andrea Mantegna.
The Adoration of the Magi
[detail].

THE CONDITION OF THE PAINTING

It is an unfortunate fact that distemper paintings are as fragile as they are beautiful. Relatively few survive, and even fewer are in good condition. While the power of the image in *The Adoration of the Magi* endures, its basic appearance has changed considerably from the time it left Mantegna's studio.

The actual losses of original paint are evident in the X-radiograph, where they stand out as darker spots. Structural damage to the linen is confined to a horizontal crease at about the eye level of the Madonna and a tear that begins near her cheek, running across the Child's exposed shoulder to terminate just beyond his upraised hand. The head of the Madonna is beautifully preserved, but many small pieces of paint have flaked off the linen elsewhere. These losses are particularly concentrated in the vessel at center and in the head of the black magus [FIGURE 6]. Luckily, no essential parts of this head were lost, so its beauty and vivid expressiveness can still be appreciated.

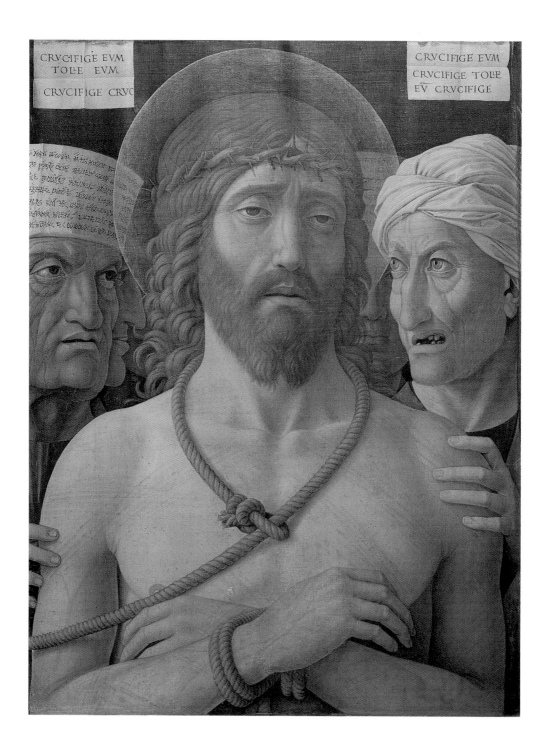

As the reader has no doubt discovered, losses of original paint can be discerned in photographs without the help of the X-radiograph. Visitors to the Getty Museum will also find that the restoration generally does not attempt to hide the losses, but merely tones them close to the original so that when the viewer steps back, he or she can appreciate the painting as a whole. Up close, the losses are detectable to the naked eye as depressions in the thin paint layer.

The losses of paint in *The Adoration of the Magi* are no more than one might find in an oil or tempera painting of similar age. However, the painting has undergone far more fundamental changes that emphasize the particular fragility of the medium. The main problem with distemper is its beautiful, unvarnished surface. Without the protection of varnish, the paint remains quite vulnerable to deposits of dirt and soot, as well as to water damage, unless it is carefully framed behind glass. The soluble character of the paint also makes it very difficult to clean and restore once damage has occurred.

As museum visitors know, glass inhibits the appreciation of a painting, and perhaps for this reason many works in distemper were displayed unprotected. However, the greatest enemy of distemper has not been the action of dirt or water on the unprotected surface but that of well-intentioned restorers who were unfamiliar with its characteristics. As *The Adoration* and many other paintings like it were obscured by gradual accumulations of grime, coats of varnish were applied in misguided attempts to restore the intensity of the colors. Varnish acts to saturate and brighten oil and tempera colors (which dry waterproof), but it has the opposite effect on distemper because the varnish is absorbed by the inherently lean and dry paint. The varnish stains the paint, causing many of the colors to darken, while others can become uncharacteristically translucent, throwing off the balance of hue and tone achieved by the artist. Overall, the beautiful matte effect and brilliant clarity of distemper is replaced by an uncharacteristic sheen. While excess varnish was removed when *The Adoration of the Magi* was recently cleaned, there is no safe means of removing it entirely.

The *Ecce Homo* in Paris [FIGURE 7] is the only distemper painting by Mantegna that has survived in truly extraordinary condition. Thanks to the fact that it was never varnished and that it was probably kept behind glass, this work can serve as a guide in envisioning the original appearance of *The Adoration of the*

Figure 7
Andrea Mantegna. *Ecce Homo*, 1500–1506. Distemper and gold on linen, 54 × 42 cm (21 ¼ × 16 ½ in.). Paris, Institut de France, Musée Jacquemart-André (221045).

9

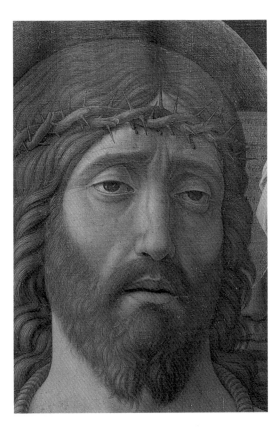

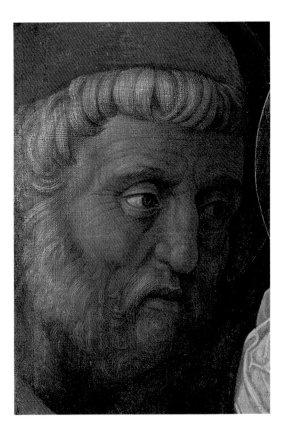

Magi.[2] A comparison of details from the Getty painting and from the *Ecce Homo* will illustrate the effect of varnish. If we study the difference in the appearance of hair [FIGURES 8–9], wrinkles in skin [FIGURES 9–10], and drapery folds [FIGURES 10–11], it is apparent that the varnished painting has lost a bit of Mantegna's razor-edge sharpness in the definition of forms, as well as the clarity and vivid brilliance characteristic of distemper colors.

If we could turn back the clock on *The Adoration of the Magi*, we would find an image with far greater visual power. From the dark ground, the forms would emerge in even stronger relief as both the sharp definition of edges and the smooth modeling of forms would gain clarity. The painting that now looks somewhat monochromatic would take on a rich panoply of colors, from a more vivid gold headdress of the Madonna to a symphony of reds, blues, and greens in the costumes and props. Textures that now recede, as in the fur on the magi's cos-

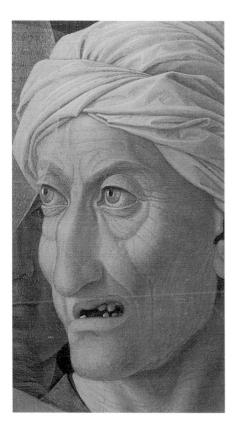

tumes, would add visual variety, as would the now-faint gold-shot effects in the Madonna's bodice and on the turban of the central magus. Finally, a matte, perfectly uniform paint layer of great thinness would complement the terse composition. But while the condition of the painting has been compromised, Mantegna's image is nonetheless still vivid, and this is an even greater testament to the power of his art.[3]

Figure 10
Andrea Mantegna.
Ecce Homo [detail].

Figure 11
Andrea Mantegna.
The Adoration of the Magi [detail].

THE HISTORY OF THE PAINTING

We know nothing of the whereabouts of *The Adoration of the Magi* until its first recorded public exhibition in 1871 at the Royal Academy in London. It was lent to the annual old masters exhibition there by Louisa, Lady Ashburton, but it is not known how long the painting had been in her family's collection. On Lady

Ashburton's death in 1903 the painting was inherited by her grandson, and it passed into the collection of the marquess of Northampton at Castle Ashby, Northants. Financial difficulties in maintaining a large estate forced the seventh marquess to sell the painting at Christie's auction house in London on April 18, 1985, when it was bought by the Getty Museum.

In 1901, the astute critic Charles Yriarte became the first to fully recognize and write about Mantegna's *Adoration of the Magi*.[4] However, a few later scholars questioned the attribution, some because of confusion with a rudimentary copy in the Johnson Collection, now at the Philadelphia Museum of Art. Still others, who could not claim confusion, rejected the Getty painting along with many of Mantegna's late devotional pictures for their frank, "in your face" appeal to the emotions.[5] This factor was so off-putting, so alien to a purist's picture of an emotionally detached, antiquarian artist, that some historians refused to see Mantegna's hand, even though no other artist was even remotely capable of authoring these works. In actuality, the painting was known to few in the original before it appeared in an exhibition in 1981, when it was fully redeemed as a profound, late product of the master.[6]

THE PAGES AHEAD

Let us begin to explore this work by one of the acknowledged giants of Renaissance painting. We will first consider the artist and his milieu by concentrating on his grand public commissions, always focusing on the aspects of his character and style that pertain to *The Adoration of the Magi*. Of special interest will be his response to revolutionary artistic theories of his time, particularly those that influenced his self-image as an artist—a learned interpreter of subjects to elevate the human spirit.

Turning from his large and famous projects, we will examine his work as a devotional painter. After a brief survey of devotional practices of the day, we will analyze Mantegna's representations of the Madonna and Child because of their importance to the topic at hand. This will lead us to explore his relationship with relief sculpture, in particular those of Donatello. Examples of devotional works relating to Christ's Passion will demonstrate Mantegna's drive to produce innovative, emotive images that seize the viewer's attention.

The theme of the Adoration of the Magi and its significance in Christian theology, liturgy, and devotion will be briefly explored. We will investigate some of the ways artists have depicted the subject, including an analysis of Mantegna's one surviving earlier rendition, in order to understand fully his innovation in *The Adoration of the Magi*.

A brief chapter will examine Mantegna's invention of the half-length narrative format and its relationship to devotional imagery. We will consider this invention in light of his desire to create modern equivalents for ancient types, and then return to the *Ecce Homo* in Paris to analyze its dramatic use of the half-length composition.

Focusing once again on *The Adoration*, we will take a closer look at Mantegna's treatment of the subject, concentrating on his particular inventions to convey the essential message of the theme. Finally, we will examine the significance of the artist's point of view to the meaning of his work of art.

Mantegna's Work and World

In the bronze bust of Andrea Mantegna in his memorial chapel [FRONTIS-PIECE], we are confronted with the keen, scrutinizing eyes and grave countenance of one of the great visual thinkers of the Renaissance. His stern visage not only conveys the strong intellect that was behind his art but also reveals something of his cantankerous character, well known even to his benefactors. The classical Roman portrait form and the laurel wreath he wears tell us of his regard for antiquity, while the crisp precision with which the bust is modeled, from the incised features to the definition of individual strands of hair, indicates that Mantegna himself may have sculpted the bust.[7] The very existence of the monument is extraordinary for an artist of his era and reflects Mantegna's status as one of the first painters to advance from a craftsman to an intellectual.

The Adoration of the Magi was created about 1500, near the end of a long and illustrious career during which Mantegna produced some of the most outstanding images of his time.[8] Possessing great technical virtuosity, extraordinary intelligence, and supreme self-confidence, he was a great innovator—a thoughtful practitioner who pushed the very boundaries of art. Displaying a profound understanding of the gravity and the grandeur of ancient art, Mantegna's works are among the earliest manifestations of that self-conscious revival we call the Renaissance. Mantegna's art concentrates on the figure as the primary expressive tool. Although often criticized for its sculptural hardness, the artist's style is balanced by his deep concern with conveying basic human qualities to involve both the intellect and the emotions of the viewer. The following pages will briefly consider some of the main features of Mantegna's oeuvre, focusing on those innovations and obsessions that will be most important in considering the Getty *Adoration*.

Mantegna was born in late 1430 or in 1431 in the village of Isola di Cartura, a few kilometers north of Padua. His father's earnings as a humble carpenter were not enough to provide an education for the boy, but his intelligence and talent must have been evident at an early age, for in 1441 or early 1442, Andrea was

apprenticed to the Paduan painter Francesco Squarcione (1394 or 1397–1468). Squarcione is remembered more as a teacher than as a painter because his school provided plaster casts of antique statuary, as well as paintings and drawings, for his students to copy, which was quite an innovative teaching method at the time.

Padua sustained a unique atmosphere for serious study, particularly of ancient life and culture. The city was one of the foremost humanist centers, principally because of its fine university, which offered a broad curriculum that attracted eager minds from all over Europe. Most important was theology, the central discipline of the late Middle Ages, but students could also study philosophy as well as the ancient group of liberal arts: grammar, logic, and rhetoric, along with geometry, arithmetic, astronomy, and music. Padua also provided for the study of natural science, anatomy, medicine, and astrology. Ancient texts were revived for the curriculum, just as casts of ancient sculpture became models for artists.

Padua was proud of its glorious Roman past as Patavium. Here, far more than in Rome itself, we find the enthusiastic revival of ancient culture that heralds the beginning of the Renaissance. Ultimately, the urge to imitate antiquity was based on the hope of regaining past glory. The remains of Roman civilization were visible all around the city, both in ruined buildings and in the ancient sculpture so avidly sought by collectors. It is no wonder that Mantegna's formative years in Padua led to an enduring dialogue with the art of the ancients.

The obsession with the culture of their glorious Roman ancestors was not by any means confined to academia. Parents even began to choose names like Caesar, Hercules, and Aeneas for their children rather than the customary saints' names. The cultural phenomenon was also embraced by the Church, led by humanist ecclesiastics, who chose to stress the cultural continuum, rejecting long-held fears of pagan corruption. After all, Christ had chosen to be born during the peace established by the Roman emperor Augustus and, ultimately, the Church would triumph over pagan forces, becoming the state religion under Constantine. In the Renaissance, Christian artists happily appropriated the clarity and monumentality of ancient style for their own purposes.

Just after 1450, in a cycle of wall paintings in the Ovetari Chapel in the Ermitani Church in Padua [FIGURES 12–13], Mantegna realized one of the great pictorial re-creations of ancient Rome as a setting for depicting scenes from the lives of the saints. The frescoes, among the first in a complete and truly Renaissance style, were a highlight on the itinerary of every artist and art lover visiting northern Italy until March 11, 1944, when stray United States bombs aimed at the nearby train station destroyed most of Mantegna's work.

In these frescoes the artist demonstrates his life-long obsession with creating highly plausible representations of his subjects. First, we note Mantegna's concern for establishing a believable three-dimensional space. The technique of achieving this on a two-dimensional surface is called perspective. Artists had long employed intuitive techniques based on their observation of optical phenomena. However, in the first half of the fifteenth century, a few advanced artists, mainly in Florence, developed a rigorous system of organizing the recession of space with a basis in mathematics, geometry, and optics. While working in the Ovetari Chapel, Mantegna must have learned what we call one-point perspective. It is based on the optical perception that parallel lines seem to converge as they recede into the distance, much as railroad tracks seem to do. Thus, all lines perpendicular to the picture plane (or running back into the space of the painting from the painting's surface) converge at a single point, far on the horizon, called the vanishing point.

Mantegna's *Saint James Baptizing Hermogenes* [FIGURE 12] and *The Trial of Saint James the Greater* [FIGURE 13] are evidence that he had mastered one-point perspective because, although the two scenes are independent compositions, they share the same illusionistic space, unified by a common vanishing point concealed by the frame between them. The marble tiles form a diminishing grid to establish not only convincing spaces, but also the relative sizes of figures and objects according to their distance from the surface. In this, one of the most astonishing debuts in art history, Mantegna achieves a dramatic spatial projection on a monumental scale unknown even in contemporary Florence.

We do not know who inspired Mantegna to master perspective, but perhaps it was Donatello, the greatest artist of the day. Donatello worked in

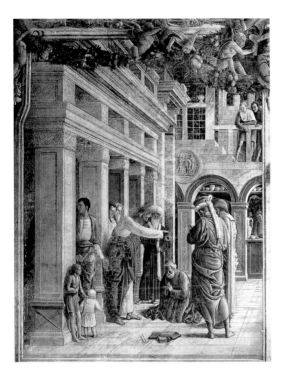 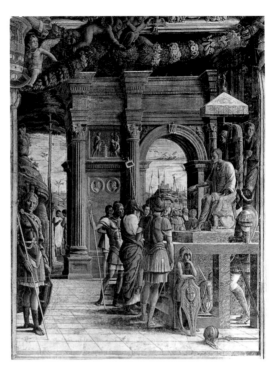

Padua between 1443 and 1454, principally on the high altar of the Church of Sant'Antonio.[9] In 1450, as Mantegna grappled with perspective for the Ovetari Chapel, Donatello was just completing some narrative reliefs for the Santo altar [FIGURE 14]. For the young Mantegna, these reliefs might have indicated the value of perspective in creating appropriate, realistic settings for the world and time of the saints.

It is also possible that Mantegna discovered perspective about this time through his future father-in-law and artistic mentor, Jacopo Bellini (1404–1472), the most imaginative artist in Venice.[10] His art is principally known to us through two notebooks of drawings that he executed from about 1440 until his death, in which studies of the nude and copies after ancient monuments reveal a Gothic artist emerging into the Renaissance [FIGURE 15]. These served as model books for his workshop, treasure troves of ideas and inspiration in the creation and reproduction of compositions. As we will see, Jacopo's elegant drawings inspired his sons and son-in-law for many years to come.

Figure 12
Andrea Mantegna.
*Saint James Baptizing
Hermogenes*, 1450–
1451. Fresco. Formerly
Padua, Chiesa
degli Eremitani, Ovetari
Chapel, destroyed.
(Photo: Alinari/Art
Resource, New York.)

Figure 13
Andrea Mantegna.
*The Trial of Saint James
the Greater*, 1450–
1451. Fresco. Formerly
Padua, Chiesa
degli Eremitani, Ovetari
Chapel, destroyed.
(Photo: Alinari/Art
Resource, New York.)

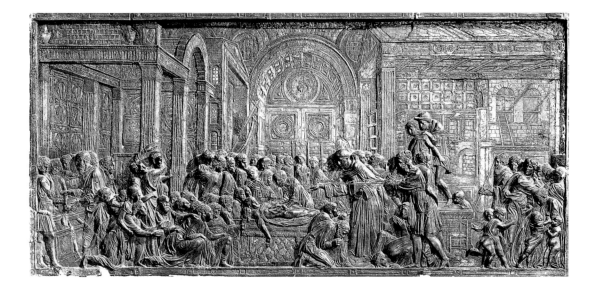

Figure 14
Donatello (Donato di
Niccolò di Betto Bardi)
(Italian, 1386[?]–1466).
*Saint Anthony's Miracle
of the Miser's Heart*,
1447–1450. Parcel-gilt
bronze, 57 × 123 cm
(22½ × 48½ in.).
Padua, Basilica del
Santo. (Photo: Alinari/Art
Resource, New York.)

Figure 15
Jacopo Bellini (Italian,
circa 1400–1470/71).
The Funeral of the Virgin
(Louvre Album 28),
circa 1450. Brown ink
on vellum, 42.5 × 29 cm
(16¾ × 11⅜ in.). Paris,
Musée du Louvre,
Cabinet des Dessins
(R.F. 1495/28).

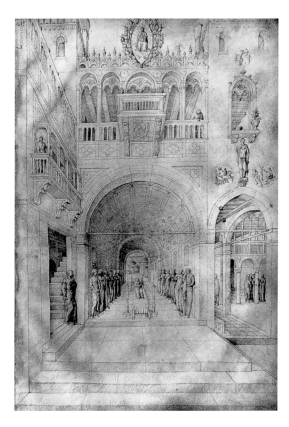

Drawings from the book demonstrate a thorough appreciation of perspective and an imaginative reconstruction of ancient splendor that must have challenged Mantegna. Bellini's influence on the younger painter was quite profound and extended to his early appreciation of nature, his strong sense of color, and his desire to invent new ways of presenting old subjects. Yet a comparison of Bellini's perspective construction with Mantegna's in the Ovetari Chapel demonstrates that the younger artist already had a better sense of the monumental character of Roman architecture. In a similar vein, Mantegna's feeling for narrative clarity would never allow the main scene to be overwhelmed by the architecture as it is in Bellini's drawing. Mantegna's ambition is impressive because in attempting to outdo Bellini and Donatello the twenty-one-year-old artist was taking on innovative achievements by the best artists of his day.

Perspective was only one of Mantegna's naturalistic concerns in painting the Ovetari Chapel. The frescoes are also animated by an anecdotal realism and a sense of humor that would become two of the most recognizable aspects of Mantegna's art. Thus, in the *Saint James Baptizing Hermogenes* [FIG-URE 12], the boy huddled against the pier at left restrains his little brother from bolting into the sacrament in progress. Another little boy stands guard against the partition in the foreground of the *Trial of Saint James* [FIGURE 13]. Comically, his helmet is too large for him; as he glances one way, the face on his shield looks the other. While Mantegna's figures were criticized for their stiffness, implying too great a dependence on ancient statuary, they already indicate that body language would become one of this artist's key expressive tools.

Here, Mantegna's great devotion to classical art is conjoined with an abiding love of stone, particularly in the depiction of sculptural relief. Mantegna's pride in his achievement is evident: the Roman soldier leaning against the central frame, gazing down at us intently, is the artist himself.

THE ALTARPIECE FOR SAN ZENO

Mantegna's first major altarpiece, executed in 1456–59 for the Church of San Zeno in Verona [FIGURE 16], shows a similar concern for illusionism, that is, creating a believable space for the depiction of the saints. The columns of the sumptuous frame appear to be engaged with piers in the painted composition.

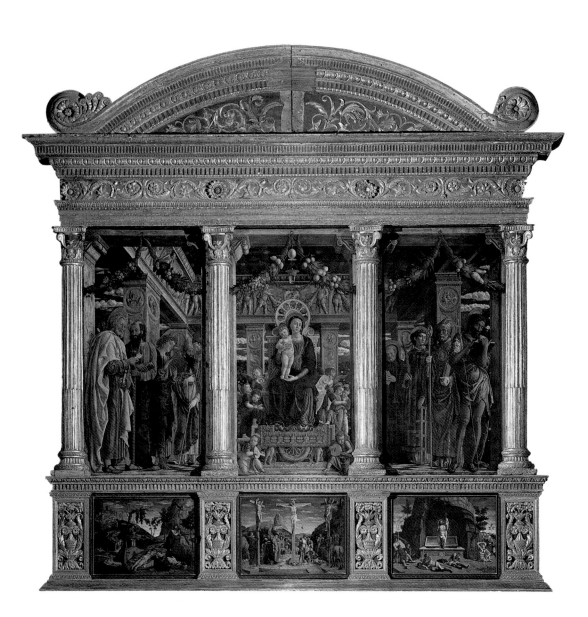

These form one side of an airy loggia in which the Madonna is presented enthroned with the Christ Child, accompanied by saints. Mantegna was not the first to impose a unitary composition on three panels in an altarpiece. However, he transformed the common Gothic scheme of depicting individual saints in separate panels into a unified space of such profound realism that the work ensured his fame as the instigator of the illusionistic altarpiece in north Italy. This realism not only results from the perception that the figures inhabit the same space, but the fact that they work together as an emotive unit as well, interacting to establish an air of pious solemnity.

A study in the Getty Museum [FIGURE 17] for the left panel of the alterpiece shows that the artist conceived of the group as unified, spatially and emotionally, even though he subsequently refined the attitudes of the saints. It demonstrates that the frame, probably also designed by the artist, was integral to his illusionistic conception. The sure, steady pen lines that define and model the figures indicate that this drawing was not a rapid early study, but that it was probably intended to present his conception to his patron.

The architecture that defines the rational space also proclaims the Renaissance with painted reliefs that challenge their ancient models. Meanwhile, strung from the architecture are lush garlands of greenery and fruit, reflecting those in the feigned reliefs as if to stress the continuity between the eras, or perhaps the power of the painter to evoke both sculptural representation and actual garlands. The wheel atop the Madonna's throne beautifully echoes her halo as well as the form of the rose window at the other end of the nave of San Zeno.

The concentration on illusionism in the San Zeno altarpiece indicates that from virtually the beginning, a central concern of Mantegna's art was involving the spectator, bridging our world and the world of art. Of course, all art does this to a greater or lesser extent, but here the artist goes to great lengths to make us feel visually and emotionally engaged.

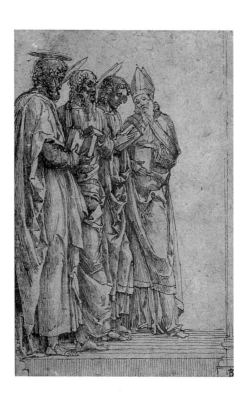

Figure 17
Andrea Mantegna.
Four Saints, circa 1456.
Pen and brown ink on
paper, 19.5 × 13.2 cm
(7 ¹¹/₁₆ × 5 ³/₁₆ in.).
Los Angeles, J. Paul Getty
Museum (84.GG.91).

Opposite:
Figure 16
Andrea Mantegna.
*The Madonna and Child
Enthroned with Saints*,
1456–1459. Tempera
and gold on wood,
H: 220 cm (86 ½ in.).
Verona, Church of San
Zeno. (Photo: Scala/
Art Resource, New York.)

21

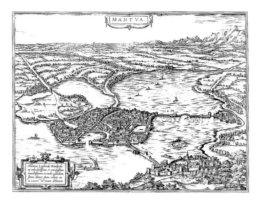

To Mantua

In 1457, Mantegna accepted the invitation of Lodovico Gonzaga, marquis of Mantua, to enter his service. Mantua [FIGURE 18] was one of the most splendid and enlightened of Renaissance city-states, and the court of the Gonzaga would provide Mantegna with his principal work for the remainder of his life.[11] When he accepted the marquis's invitation, Mantegna entered an elite group. While he was no longer free to accept commissions from any patron—even the pope had to appeal to the marquis to gain his services—Mantegna did not have to depend on the vicissitudes of the open market. While the duties of a court artist could be onerous, three generations of Gonzaga provided enlightened patronage that did not overtax his genius with petty duties. They seem to have understood all along that Mantegna would bring them glory, even though they often found his slowness in producing work exasperating. Meanwhile, the humanist spirit of the court was to provide this artist with an environment that would cultivate his talents to the fullest.

A far cry from the cosmopolitan and university atmosphere of Padua, Mantua remains to this day a small city, perched at the conjunction of three lakes formed by the River Mincio. The geographical situation had its drawbacks as malaria regularly emerged from the swamps, but it also generated the sense of a detached, floating world with sparkling light that Mantegna captured in the background of a work painted not long after he moved to the city in 1460 [FIGURE 24].

Mantua had existed as a small settlement in Roman times. The Roman poet Virgil (70–19 B.C.) was born there, but even a native son was impelled to

note that the area was impoverished. Mantua did not come into its own until the Gonzaga seized power from the rival Bonacolsi family in 1328, consolidating their hold on the city over the next century. Mantua was legally a fief of the Holy Roman Emperor, and in 1433, the hereditary title of marquis was bestowed on Lodovico's father by Emperor Sigismund (primed by a donation of 12,000 florins).

The territories belonging to the Gonzaga were not large enough to sustain their court, and the marquises supplemented their income by hiring themselves out as *condottieri*, or mercenary generals, in the noble profession of war. Lodovico was renowned for his courage and ferocity in battle, but he was not only a soldier. He had received one of the best humanist educations of his day from Vittorino da Feltre, his tutor, whose advanced school in Mantua provided instruction in the liberal arts as well as subjects, such as Roman history and ethics, geared for educating princes. Lodovico's enlightened humanism is revealed not only in his wise governance, but also in the grand projects he undertook to demonstrate the magnificence of his rule, emulating the emperors of Rome.

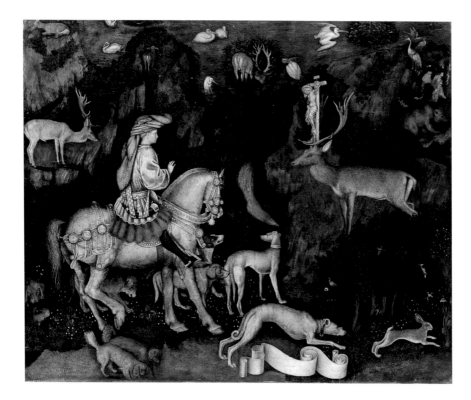

Figure 19
Pisanello (Antonio Pisano) (Italian, circa 1395–probably 1455). *The Vision of Saint Eustace*, mid-fifteenth century. Tempera on wood, 54.5 × 65.5 cm (21 7/16 × 25 3/4 in.). London, National Gallery (1436).

In the years just before Mantegna was brought to the court, the Gonzaga had favored the art of Pisanello (about 1395–probably 1455), whose vision of courtly splendor can be seen in a charming painting of Saint Eustace [FIGURE 19], possibly painted for the court of Mantua.[12] The artist re-creates the tale of a Roman general, who was converted to Christianity by a vision of the Crucifix between the antlers of a stag while out hunting. Eustace is nonetheless depicted as a fashionable, mid-fifteenth-century soldier-prince amid an assembly of naturalistic animals. The artist revels in the depiction of nature's rich variety, but his space is built like that found in late Gothic tapestries, stressing surface pattern over spatial projection. Could there be a more distinct world from that created by Mantegna in the contemporary Ovetari Chapel frescoes? When Lodovico hired Mantegna, it signaled his partisanship of the antique manner and his decision to bring the best exponents of the new style to Mantua.

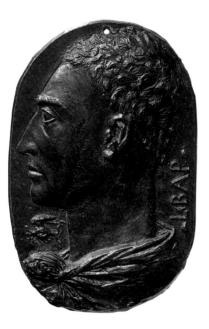

Foremost in the effort to establish the *all'antica* style in Mantua was Leon Battista Alberti (1404–1472) [FIGURE 20], the brilliant humanist, antiquarian, and architect. By the middle of the fifteenth century Alberti was one of the preeminent architects for those who wanted to revive the ancient way of building. For Mantua, he designed two churches in the new style, but Sant'Andrea [FIGURES 21–22], begun in the year of his death, is generally recognized as his most complete work and one of the great monuments of Renaissance architecture.[13] The powerful façade is inspired by Roman triumphal arches, while the interior presents a single-aisle plan based on the barrel-vaulted chambers of ancient Roman temples. In façade and interior alike, there is a sense of monumentality that had been unknown since the days of the Empire. Appropriately, the remains of Andrea Mantegna rest here, in the first chapel on the left [see FRONTISPIECE].

There was also a sculptor who played a major role in creating the antique setting for the court of the Gonzaga. Pier Jacopo Alari Bonacolsi (circa 1460–1528), known by the nickname "Antico," worked with Mantegna, who must have exerted a strong influence on him. Trained as a goldsmith, Antico became

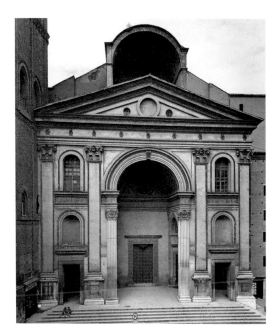

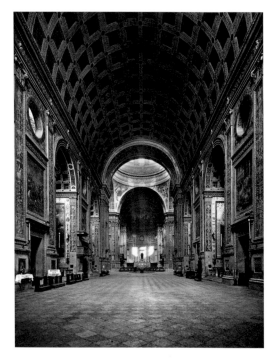

Figure 21
Leon Battista Alberti.
Façade of the Church
of Sant'Andrea, Mantua,
begun 1472.
(Photo © Rollie McKenna.)

Figure 22
Leon Battista Alberti.
Nave of the Church
of Sant'Andrea, Mantua,
1472–1494. (Photo:
Getty Research Institute,
Research Collections,
Los Angeles.)

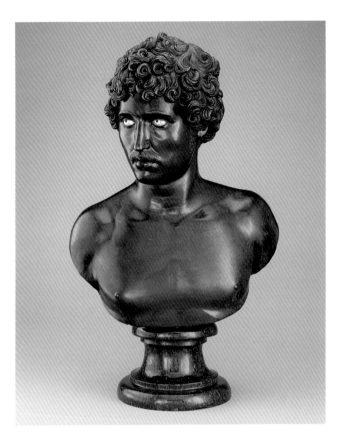

renowned in particular for small bronze figures, but he also created modern equiv-
alents of larger antique statuary. His *Bust of a Young Man* [FIGURE 23], executed
about 1520, is based on an ancient marble.[14] Here the use of silver inlay for the
eyes emulates a frequent ancient practice that seldom survives owing to pilferage.
In spite of his archaeological accuracy, Antico's art is also quite contemporary; the
precious finish of his works is the equivalent of Mantegna's meticulous detail.

ALBERTI'S THEORIES AND
MANTEGNA'S IDENTITY AS A PAINTER

As Alberti returned to the Mantuan court with some regularity, he and Mantegna
surely became acquainted. The architect was the greatest living theorist on the
art of painting, having completed his renowned book *On Painting*, the earliest

known theoretical work on the topic, in 1435.[15] As we are about to see, Mantegna's art represents the creative use of Alberti's theories by a brilliant practitioner.

On Painting was completely original. While Vitruvius's tomes on architecture had survived from the ancient world, and contemporary manuals of shop practice existed for the painter, Alberti's treatise is the first major literary work on the art of painting. The Latin text of the original indicates that he intended it for a scholarly audience, to establish the theoretical basis for painting as an intellectual practice. In it he lays down a set of moral and aesthetic principles he derived from studying ancient art, what the ancients wrote about their art, and ancient literary theory, commingled with contemporary ideas gleaned from advanced artists in his native Florence. That Alberti was equally committed to influencing practicing artists is evidenced by his quick translation of the Latin text into Italian, finished by 1436.[16]

Alberti's treatise represented a fundamental change in the concept of the painter and his art. No longer the simple artisan, the Albertian painter becomes the learned creator and commentator. Alberti, and later Mantegna, understood that this had to come about by the assimilation of art into humanist culture. That was not an easy task because painting was traditionally considered a craft and had never been included among the hierarchy of liberal arts established in the late antique world.

Lacking a classical theoretical basis for painting, Alberti turned to one of the liberal arts, rhetoric, as well as to the practice of history in antiquity and the Middle Ages, for principles. Alberti designates that the prime goal of painting is *historia*. This term is usually translated as "history painting," or the depiction of lofty subjects from literature as well as history, but this oversimplifies a complex concept. By using this term, Alberti did not mean storytelling pure and simple, but storytelling as a means of moral and intellectual instruction.[17]

From rhetoric and history, Alberti distilled the basic principle that *historia* should convey a multiplicity of higher meanings. The literal sense of narrative, the reporting of facts and fidelity to sources, was important, but *historia* was not meant to be a pictorial re-creation of an event as it might have appeared to an onlooker, but rather a learned interpretation that would reveal the quintessential meaning of the subject to the viewer.

Alberti's concept of *historia* challenged painters to adopt new creative approaches to familiar narratives. In particular, the painter was exhorted to study nature and ancient art as the best sources for shaping fresh, plausible representations of subjects. Believability was deemed highly important, and to further it Alberti offered an advanced perspective system that was perhaps the one Mantegna learned.

Mantegna's precociousness as a creative painter of *historia* is revealed in an early work for the Gonzaga, *The Funeral of the Virgin* [FIGURE 24], one of a series of paintings installed in the chapel of the Castello di San Giorgio, the marquis's principal residence. The space in the painting is clearly laid out on a perspective grid and is defined by classical architecture that once included a barrel vault at the top.[18] Mantegna was probably inspired by Jacopo Bellini's rendition of the subject [FIGURE 15], but the younger artist goes beyond his mentor to reveal a highly developed understanding of Alberti's principles.

Alberti taught that form and composition are as integral to the work of pictorial art as to the rhetorical forms of literature and history; only the vocabulary was different.[19] For Alberti, composition, gesture, and expression were the means by which painting takes on the expressive significance of *historia*. Thus, to stress the solemnity of the event, Mantegna adopts Bellini's dramatic scheme of positioning the Virgin's catafalque at the end of a narrow chamber lined by singing apostles. However, Mantegna turns the bier to give us a better view of the Madonna and to emphasize the ritual actions being performed. For Alberti, the ultimate goal of *historia* was the emotional identification of the viewer with the action or moral significance of the scene. Here, the closer view allows us to see how Mantegna varies each expression and gesture to express individual states of sorrow, leading the viewer to an appropriate state in meditating on the death of the Mother of God.

Mantegna also employed other means to engage the viewer. While he follows the main textual source for this scene in Jacopo da Voragine's *Golden Legend*, he augments it with contemporary liturgical practice, including the use of the censer, to heighten the sense of truth announced by the familiar view. A nearby window would have opened onto just such a vista of the lake, thus giving this scene from the Life of the Virgin a directness and emotional immediacy that Alberti surely appreciated when he visited the marquis's chapel.

Figure 24
Andrea Mantegna.
The Funeral of the Virgin,
circa 1460. Tempera
and gold on wood, 54 ×
42 cm (21¼ × 16½ in.).
Madrid, Museo del Prado
(248).

28

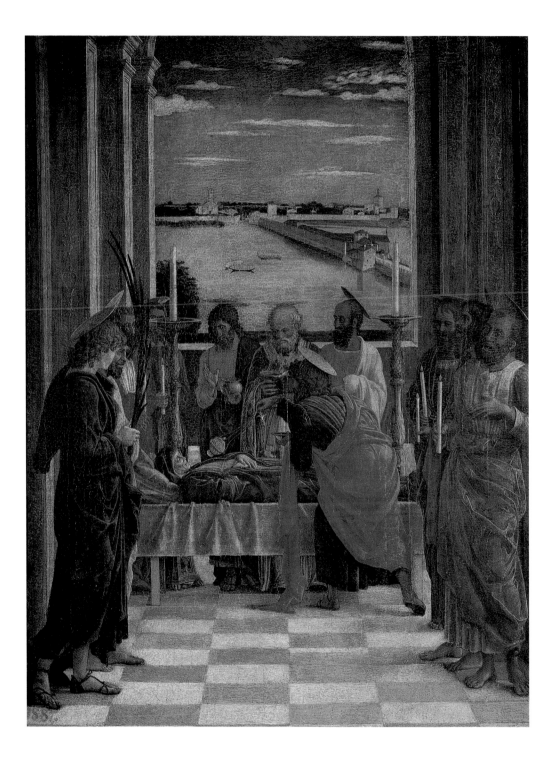

Mantegna also applied the Albertian concept of *historia* to contemporary events, picturing the Gonzaga court in a painted room [FIGURE 25] that is a masterpiece of Renaissance secular painting. Created between 1465 and 1474, the room was called simply the Camera Picta or Camera Dipinta (the Painted Chamber) by contemporaries.[20] According to the customs of the day, this room served numerous functions: not only the place where Lodovico managed the internal and external affairs of his state, but an audience chamber, a family gathering place, even sometimes a bedroom.

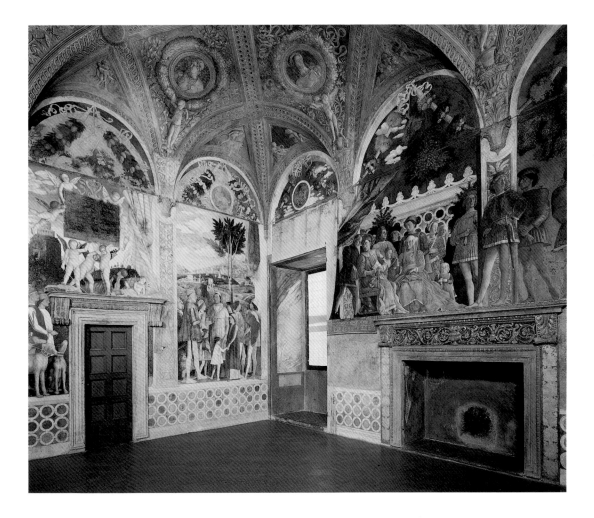

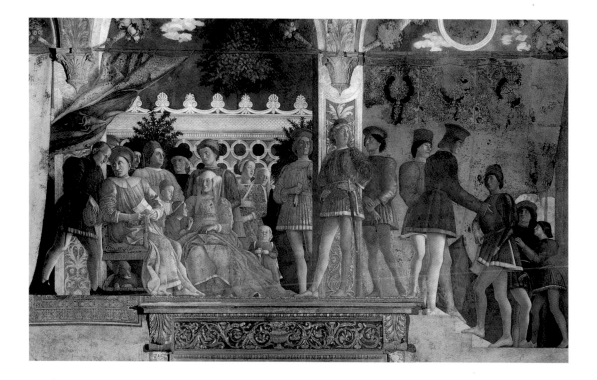

On the north wall [FIGURE 26] Mantegna throws back a splendid illusionistic curtain to show Lodovico as the Renaissance prince at the center of his court. The marquis has just received a dispatch and is presumably issuing a response to a councilor. At his side is Barbara of Brandenburg, the niece of Emperor Sigismund betrothed to Lodovico as part of the bargain when the Gonzaga became titled. The lady Barbara, who legitimized Lodovico's rule and provided some luster to the Gonzaga family tree, is depicted as his partner. She fulfilled this role admirably, often managing the affairs of family and state when her husband was off in the battlefields. Gathered around the marquis and his consort are not only their children, but also the extended family of the court: scholars and dwarfs, nurses and courtiers, all striking attitudes that express their station in life.

The composition, clearly divided at the pilaster between the inner sanctum of the marquis and the outer world of the court, illustrates the political reality of a Renaissance city-state. This family portrait is carefully contrived to project the image of the born ruler who governs with the ease and wisdom of a

Figure 26
Andrea Mantegna.
The Court of Lodovico Gonzaga, north wall of the Camera Picta, 1465–1474. Fresco. Mantua, Palazzo Ducale, Castello di San Giorgio. (Photo: Scala/Art Resource, New York.)

Opposite:
Figure 25
Andrea Mantegna.
West and north walls of the Camera Picta, 1465–1474. Fresco. Mantua, Palazzo Ducale, Castello di San Giorgio. (Photo: Scala/Art Resource, New York.)

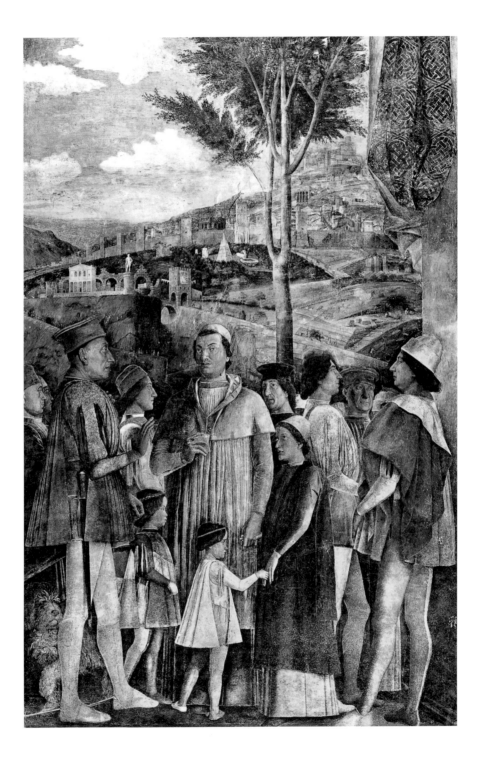

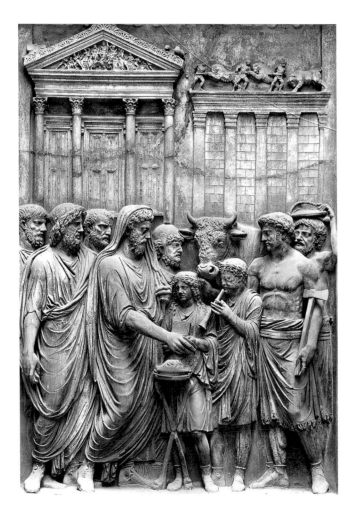

good father. The comings and goings indicate that the world comes to Lodovico, enthroned in his castle; from this stronghold his will is taken into the outer world and enacted.

The west wall is given over to exterior scenes, including one [FIGURE 27] of Lodovico meeting his son, Cardinal Francesco Gonzaga, and his entourage. Here, Mantegna quite self-consciously models his composition on the formula of an ancient relief [FIGURE 28], not only disposing the figures close to the picture plane but also building the landscape vertically. The frozen quality in the attitudes of the figures may indicate a classical relief source as well, just as Mantegna's counterpoint of strict profiles proclaims that this narrative is filled with portraits. The artist may not have known this particular ancient relief, at least directly, at this time because we are not aware of a journey to Rome until 1488. However, given Mantegna's acute interest in ancient Roman art and culture, it is highly likely that he would have made a visit to the Eternal City early in his career.

Rising to the ceiling, we find a rich vault of feigned architecture, complete with medallions of the Roman emperors to serve as paragons for the wise rule represented in the contemporary scenes below. Yet nothing prepares the viewer for the center of the ceiling [FIGURE 29], where the art of perspective is used in a revolutionary way: to create a convincing, illusionistic extension of the room overhead.

Mantegna uses paint to break open the architecture of the vault, creating an oculus looking up to the open sky. Once the perspectival extension of the real architecture was in place, Mantegna painted figures as if viewed from below. The positioning of the figures both behind and in front of the feigned architecture makes it all seem to exist in our space. This leap of Mantegna's imagination represents the beginning of illusionistic ceiling painting. Of his many inventions, this one exerted perhaps the most profound influence on subsequent generations, first in north Italy and then, progressively, all over Europe.

As we look up toward the sky, we realize that our gaze is being met by three young ladies of the court, who smile at us. Then, next to them, we note the large potted plant, precariously perched on a wooden dowel. The lady on the other side has her hand on the dowel and, just to make sure we do not miss this, the African maid gazes down at that hand. Are the other ladies looking down trying to distract us with their grins?

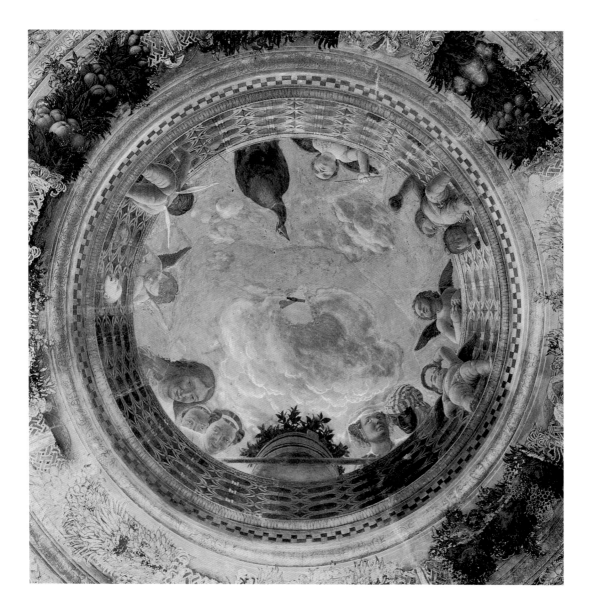

In the midst of the seeming actuality of the illusion, through the power of art, putti have magically flown in from the celestial realm and are now playfully mingling in our space. Meanwhile, a peacock, perhaps symbolizing the splendor of the court or maybe even art itself, yearns for flight, ever seeking that which is above and beyond.

Figure 29
Andrea Mantegna. Ceiling of the Camera Picta, 1465–1474. Fresco. Mantua, Palazzo Ducale, Castello di San Giorgio. (Photo: Scala/Art Resource, New York.)

Figure 30
Andrea Mantegna.
*Judith with the Head
of Holofernes*, 1490s.
Distemper on linen,
48.1 × 36.7 cm
(18 $\frac{15}{16}$ × 14 $\frac{7}{16}$ in.).
Dublin, National
Gallery of Ireland (442).

We have already noted that Mantegna was inspired by Donatello's reliefs, that he based contemporary scenes in the Camera Picta on the formula of ancient reliefs, and that he painted convincing representations of ancient relief medallions there as well. In fact, in virtually all the paintings we have seen by Mantegna so far, there is almost an obsession with depicting stone. Mantegna eventually extended this penchant to the creation of a number of independent compositions in the form of feigned reliefs [FIGURE 30].

Mantegna's fascination with the ancient relief and its potentials for modern art is best demonstrated in *The Triumphs of Caesar*, a series of nine monumental canvases depicting a triumphal procession of the victorious Julius Caesar and his army through Rome.[21] This re-creation of Roman military glory was, of course, meant to allude to the contemporary military prowess on which the Gonzaga depended.

The Vase Bearers [FIGURE 31], the best preserved among the heavily damaged canvases, shows the strong sense of forward movement that characterizes the series. Mantegna's principal visual inspirations were Roman reliefs such as

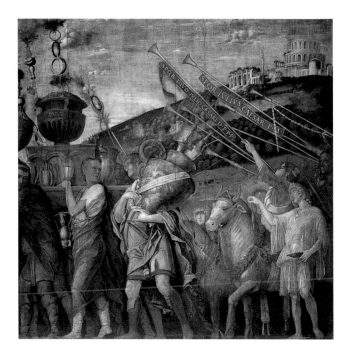

Figure 31
Andrea Mantegna.
The Triumphs of Caesar,
Canvas 4: *The Vase Bear-*
ers, circa 1500–1506.
Distemper(?) on canvas,
268 × 279 cm (105½ ×
109⅞ in.). Hampton
Court, The Royal Col-
lection, © Her Majesty
Queen Elizabeth II.
(Photo: Rodney
Todd-White and Son.)

Figure 32
The Victorious Army of
Titus with the Spoils from
Jerusalem, circa A.D. 90.
Marble, 204 × 380 cm
(80¼ × 149⅝ in.).
Rome, Forum Romanum,
Arch of Titus. (Photo:
Alinari/Art Resource,
New York.)

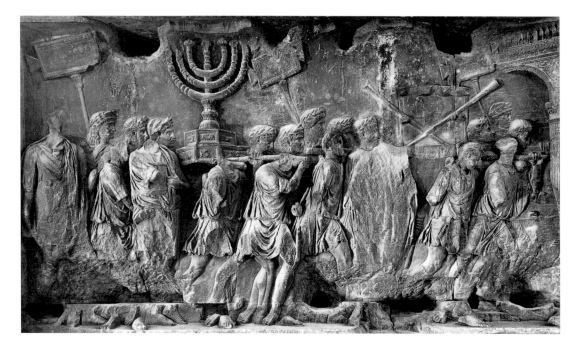

those on the Arch of Titus [FIGURE 32]. Mantegna's parade of war booty—followed by oxen adorned for sacrifice and trumpeters—roughly follows descriptions of ancient triumphs by Appian and Plutarch.

Mantegna's attitude toward historical accuracy is best indicated by the buildings in the background, which look vaguely ancient but do not correspond to real Roman structures. As his works have been studied by historians, it has become clear that Mantegna was not interested in producing an archaeologically accurate reconstruction of an ancient triumph. Instead, he wanted to produce images that convincingly evoke the grandeur of the ancient world for a contemporary audience, and in this he succeeded. When the ensemble was displayed together in its early days, it impressed even Florentine partisans such as Michelangelo and Vasari.

Toward the end of his life, Mantegna, a great cynic, became even more cynical. In spite of the continued approbation of his work by the Gonzaga, he experienced financial difficulties and felt underappreciated. Sadly, his personal life was characterized by many disappointments, most especially the mediocrity of his sons. Also, as a new century dawned, he watched as new aesthetic values, quite alien to his own, began to dominate the art of painting. Mantegna in no way compromised his style to accommodate the interest in atmospheric naturalism that was burgeoning in Venice, even in the work of his brother-in-law, Giovanni Bellini. In fact, Mantegna's style remained rather constant once it was established, but his later work demonstrates a distinctly more somber tone that would seem to reflect his outlook on life. In the altarpiece for the Church of Santa Maria in Organo in Verona [FIGURE 33], signed and dated 1497, Mantegna employs a conservative type of composition, with the Madonna and Child in a mandorla and exuberant fruiting trees that recall his origins in Padua. The figures looking down at us (the painting was placed in the high altar) have the same profound presence as those in the San Zeno altarpiece, only now without the help of architecture to establish space. The sobriety that characterizes Mantegna's expressions from the beginning here gives way to a kind of melancholy. This aspect touches many of his late works, including *The Adoration of the Magi*, which probably dates from a few years after the altarpiece. This gives these works a deep pathos that is quite engaging.

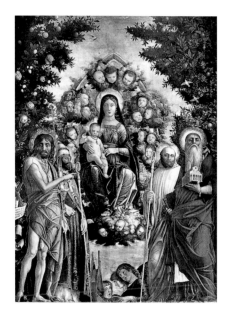

Figure 33
Andrea Mantegna. *The Trivulzio Madonna*, 1497. Tempera on linen, 287 × 214 cm (113 × 84¼ in.). Milan, Civiche Raccolte d'Arte al Castello Sforzesco (formerly Verona, Church of Santa Maria in Organo). (Photo: Alinari/Art Resource, New York.)

In this broad overview of Mantegna's public commissions we have attempted to demonstrate some of the main concerns of his art that most directly inform *The Adoration of the Magi*. We have seen him as the master of spatial manipulation, one who could create a plausible space better than any artist of his generation. Mantegna was also the master of narrative logic and clarity, whether in a scene projecting the image of the court or telling a saint's story. An intellectual, Mantegna is also eminently human and can often be found incorporating basic human situations to complement his narratives. Always aiming for both intellect and emotion, he became the unequaled master of gesture and expression. We have noted that Mantegna was a great antiquarian, yet he was first and foremost an artist, and visual plausibility won out against archaeological accuracy every time.

Mantegna also had an extraordinary fascination with relief sculpture, both ancient and modern. In his feigned reliefs, he attempts to surpass the real thing. In special narrative circumstances, Mantegna appropriated the ancient relief format for a thoroughly modern look and purpose, as we will soon discover in considering *The Adoration of the Magi*.

Mantegna and Devotional Painting

While Mantegna is principally remembered for grand murals and altar-pieces, his more intimate works for private devotion, such as *The Adoration of the Magi*, are no less innovative or compelling. Considering that he produced far fewer devotional images than his colleagues who were dependent on the open market, the range and power of Mantegna's paintings in this area are among the most impressive of any artist of his age.

To advance our study of the Getty *Adoration*, we will concentrate on devotional works depicting Christ, which tended to represent either the beginning or the end of his earthly life. Images of Christ on the Cross remained the central focus of Christian devotion, but in the fifteenth century meditation on Christ's sacrifice was expanded to include other scenes of his suffering, including several haunting images of great originality by Mantegna. Representations of the Madonna and Child had become especially popular by the mid-fifteenth century, perhaps indicating that many among the faithful found it easier to approach a picture of the infant Christ, especially with his mother, the most potent of intercessors. In each of Mantegna's treatments of the Madonna and Child, his great originality is displayed not only in bold imagery to compel the eye, but also in his ability to touch the heart.

A good devotional image, whether it takes the form of a narrative in a meticulously described setting or depicts a single holy figure in isolation, inspires the viewer to contemplation and empathetic involvement with those depicted. However, in creating works for private meditation, artists often took a lesson from the icon maker, removing the religious figures from the distractions of a narrative context to promote interaction with the viewer. By placing Christ, the Madonna, or a saint before an ambiguous background, the artist could enhance the sense of intimacy. In this section, we will treat such non-narrative paintings by Mantegna, returning to works that preserve some narrative context, like *The Adoration of the Magi*, a bit later.

Owing to the great burst of secular art and culture in the Renaissance, it is often forgotten that the most remarkable "rebirth" of all concerned the person of Jesus Christ.[22] In the early Middle Ages, the Church presented Jesus in his divine aspect, as the ruler of the cosmos who would come in glory at the end of time to judge the living and the dead. In keeping with this distant and forbidding image, the laity played virtually no active role in prayer and were only asked to memorize the basic "Our Father." Direct contact with God through prayer was treated as a specialized skill, carried out on behalf of lay people by priests, monks, and nuns in exchange for alms.

The distance of the average person from God, and particularly from his incarnation in Jesus, began to narrow in the twelfth century, led by the example of mystical theologians such as Bernard of Clairvaux. However, it was not until the beginning of the following century that Christian focus on the human nature of Jesus was brought fully into the mainstream of the faith by its most powerful advocate, Francis of Assisi. His efforts toward making religion more personally relevant included sermons in the vernacular, paraliturgical drama, and most importantly, teaching the laity how to pray and meditate. By Mantegna's day, personal prayer and meditation had become part of religious experience. The advent of the printing press brought the ability to produce devotional tracts and imagery previously only available to the rich in manuscripts. Works of art of all kinds were being created to fulfill an increasing demand for aids to individual meditation on the mysteries of the faith.[23]

It is particularly appropriate to speak of Saint Francis in this context, since devotion to the Christ Child—so well represented by the Magi scene—and joyous celebrations of Christmas and the Epiphany were largely unknown before him. He popularized the use of the *presepio*, a re-creation of the manger with a sculpted figure of the infant Jesus, for adoration by the faithful. A popular miracle associated with Francis holds that his ardent devotion before such a manger was rewarded when the sculpted Christ Child came to life for him to hold in his arms.

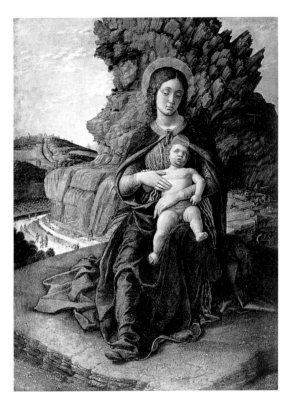 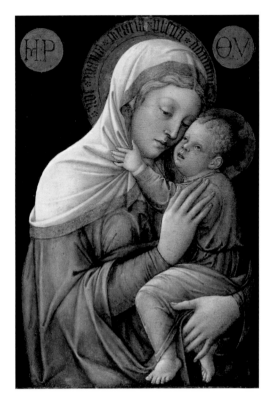

Figure 34
Andrea Mantegna.
Madonna and Child,
1470s. Tempera on
wood, 32 × 29.6 cm
(12⅝ × 11⅝ in.).
Florence, Galleria degli
Uffizi (1348). (Photo:
Alinari/Art Resource,
New York.)

Figure 35
Jacopo Bellini. *Madonna
and Child,* circa 1465.
Oil on wood, 69.7 ×
47 cm (27⁷⁄₁₆ × 18½
in.). Los Angeles County
Museum of Art
(M.85.223), Gift of The
Ahmanson Foundation.

Few things can captivate and charm people more than babies. Contemplation of the Christ Child emphasized the beautiful irony of God taking on the guise of a helpless infant to draw people to him for their personal salvation. The appeal to the emotions that Francis introduced as an integral part of devotion to the Christ Child found one of its most profound exponents in Mantegna.

MANTEGNA'S MADONNAS

Paintings and reliefs of the Madonna and Child were the bread and butter of artists' studios in the second half of the fifteenth century, and the diversity of images is remarkable considering the simplicity of the theme. Even Mantegna's limited number of examples demonstrate some of this variety. His only full-length treatment of the subject [FIGURE 34] employs landscape as a prime com-

ponent, although it is used expressively and symbolically rather than to promote a sense of narrative unity. The Madonna and Child are posed on a pebbly promontory high above the landscape, framed by a spectacular outcropping of fractured rock. The Child, contained within the strong contour of the Madonna, has been given a pained expression, an allusion to his death on the cross. Inspection of the landscape reveals that Mantegna created a quarry where a column and a sarcophagus—symbols of the Passion—are prepared before a cave that might allude to the Holy Sepulcher.

Much more common, half-length and bust-length compositions of the Madonna and Child were produced in large numbers by painters and relief sculptors alike. Some highly venerated images that originated in relief were copied by painters in their two-dimensional art [FIGURE 35]. On the other hand, reliefs were often fully colored. This blurring of the distinction between painting and sculpture reveals an underlying characteristic of fifteenth-century thinking about devotional imagery: composition and emotional communication were important; the medium was not.

The reliefs produced by Donatello and his workshop [FIGURE 36] are among the most outstanding works of this type, and their influence on Mantegna was profound.[24] While the simplicity, economy of design, and solemnity of forms of Donatello's Madonnas inspired the younger artist, it is their touching humanity that he learns the most from and then surpasses.

Mantegna's essays on the subject [FIGURES 37–39] are among the most moving expressions of the bond between Mary and Jesus ever created. In these images of the Virgin and Child in half-length against a dark ground, Donatello's lessons in the creation of visual links between mother and son through the use of strong contours and expressive, enclosing hands are evident. Here the tough artist turns tender, but without sentimentality, because in Mantegna's renditions of the Madonna and Child, reminders of Christ's role as the sacrificial Lamb of God are never far away.

Each Madonna represents a different ideal of beauty, yet in each, the Virgin is lost in melancholy at the premonition of her son's end. In Mantegna's close-up renditions of the Madonna and Child, he foregoes landscape, so the death of Christ must be called to mind by other means. Sometimes this is sug-

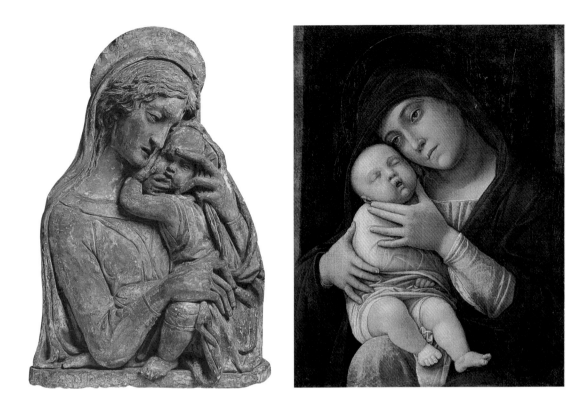

gested by depicting Jesus sleeping, a motif enlivened by Mantegna's acute observation of dozing infants. However, in the Bergamo version [FIGURE 39], the agony of Christ's Passion is evoked in a clever and most human way: the Child's pained expression clearly results from teething, as his two front teeth can be seen emerging from tender gums.

As the Madonna and Child motif was not endlessly variable, artists sought other means of honoring them. Mantegna sometimes depicted them in the context of a Holy Family group [FIGURE 40]. Such paintings could be widely varied or customized by adding to the cast, brilliantly accomplished here by stacking characters vertically in a modern adaptation of an ancient relief form. It may be that paintings like the Getty *Adoration of the Magi* were also developed from the desire to create new forms to vary standard depictions of the Holy Family.

Mantegna's output of Madonna and Child images is rather small and reflects his status as a court artist. By contrast, paintings of the Madonna and

44

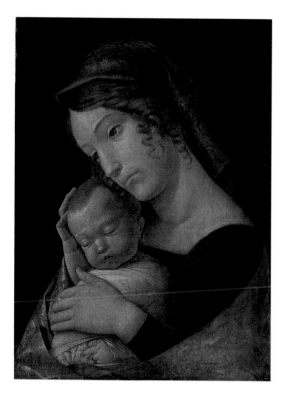 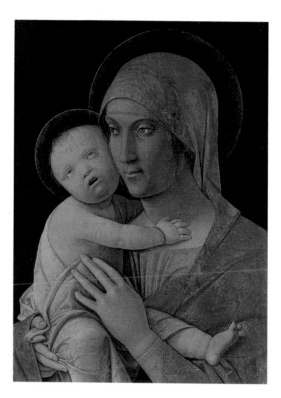

Child were a major source of income for his brother-in-law, Giovanni Bellini [FIGURE 41]. Considering that Mantegna and Bellini's familial relationship ensured that they would have serious interaction in the creation of art, it is notable how different their achievements are in this area.[25] Bellini produced a remarkable variety of treatments of this standard theme, often including other saints or donor figures. However, Bellini's Madonnas never possess the emotive power of his brother-in-law's far less conventional compositions; but then few artists ever probed the psychological dimension between Madonna and Child as vividly as Mantegna did.

Before returning to the Getty *Adoration*, we should examine two of Mantegna's devotional works that depict the end of Christ's life. These Passion subjects will even more acutely demonstrate Mantegna's drive to produce innovative images with enormous visual and emotional force.

Figure 38
Andrea Mantegna.
Madonna and Child,
1480s. Distemper
on linen, 42 × 32 cm
(16½ × 12⅝ in.).
Berlin, Staatliche
Museen, Preussischer
Kulturbesitz, Gemälde-
galerie (S.5).
(Photo: Jörg P. Anders.)

Figure 39
Andrea Mantegna.
Madonna and Child,
1500–1505. Distemper
on linen, 43 × 31 cm
(16⅞ × 12⅛ in.).
Bergamo, Accademia
Carrara. (Photo: Erich
Lessing/Art Resource,
New York.)

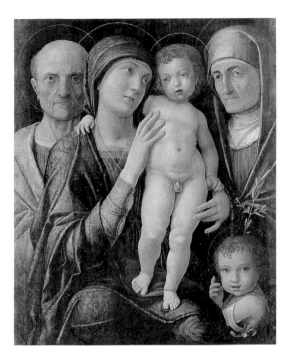

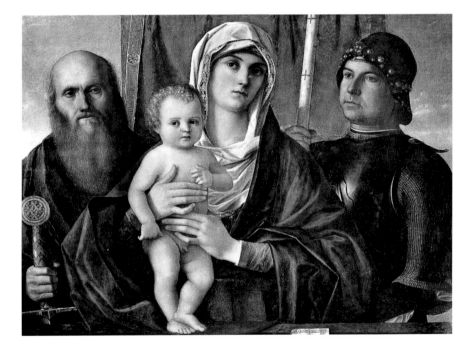

Figure 40
Andrea Mantegna. *The Holy Family with Saint Elizabeth and the Infant Saint John the Baptist*, 1500–1505. Tempera on canvas, 75.5 × 61.5 cm (29¾ × 24¼ in.). Dresden, Gemäldegalerie.

Figure 41
Giovanni Bellini (Italian, circa 1430/40–1516). *Madonna and Child Between Saints Paul and George*, circa 1490. Oil (or oil and tempera) on wood, 65 × 88 cm (25⁹⁄₁₆ × 34⅝ in.). Venice, Accademia (610–74). (Photo: Alinari/Art Resource, New York.)

One predominant devotional image of this period in northern Italy was the Man of Sorrows, in which the dead Christ is portrayed with the wounds of his Passion in isolation, that is, removed from a narrative context. In the fifteenth century, the Man of Sorrows is most usually depicted in half-length against a plain ground or a cloth of honor, as in Donatello's formulation for the Santo altar in Padua [FIGURE 42]. By contrast, Mantegna's *Man of Sorrows* [FIGURE 43], which was probably intended for private devotion, is shown full length and is placed within the landscape of his crucifixion and burial. However, abstraction from a narrative context is made clear because Christ is propped up on the end of an elegant *alla'antica* sarcophagus by two angels, one with the red attributes of a seraph, the other with the blue of a cherub. As the viewer marvels at the exquisite rendering of the landscape, it becomes clear that it is delicately bisected to evoke a pivotal moment between the Crucifixion and the Resurrection. To Christ's left, Golgotha with its crosses is seen in the light of the setting sun; to his right, the landscape lightens to evoke dawn, alluding to the coming Resurrection. Mantegna's treatment is most unusual and powerful in its biting presentation of Christ frozen in the anguish of death, with his eyes open, seemingly imploring the viewer.

Devotional focus on the body of Christ was most brilliantly achieved by Mantegna in *The Lamentation over the Dead Christ* [FIGURE 44], which rivals the overhead oculus in the Camera Picta [FIGURE 29] in its audacious use of perspective to arrest the viewer's attention. Here, the artist dramatically places the body of Christ perpendicular to the picture plane and assumes a point of view at the foot of the bier, so that a kneeling viewer mourns along with the figures at left. Unless one carefully analyzes the representation, the corpse appears remarkably natural. Perhaps achieved with a perspective grid, the foreshortening of the figure is nonetheless manipulated by Mantegna for expressive goals. For instance, the feet are much smaller than they would be if the body were consistently foreshortened, but they have been brought into line for reasons of balance and decorum. Mantegna also positions the figure to force the viewer to confront the wounds of Christ, as the faithful are exhorted to do for their salvation in popular devotional treatises.[26] Rendered with Mantegna's cus-

Overleaf:

Figure 42
Donatello. *The Man of Sorrows with Two Angels*, 1448–1449. Bronze, 58 × 56 cm (22¾ × 22 in.). Padua, Basilica del Santo, High Altar. (Photo: Alinari/Art Resource, New York.)

Figure 43
Andrea Mantegna. *The Man of Sorrows with Two Angels*, 1470s. Tempera on wood, 78 × 48 cm (30⅝ × 18⅞ in.). Copenhagen, Statens Museum for Kunst (SP 69). (Photo: Hans Petersen.)

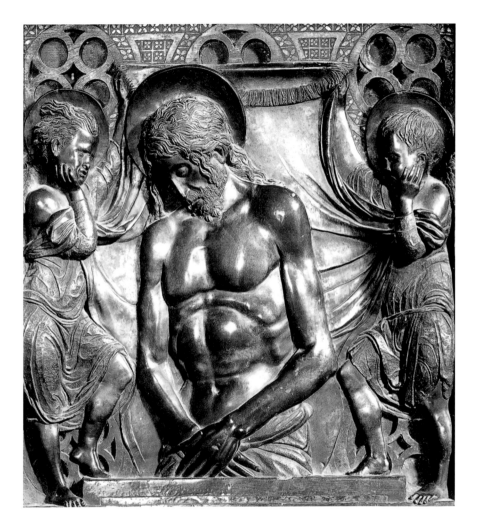

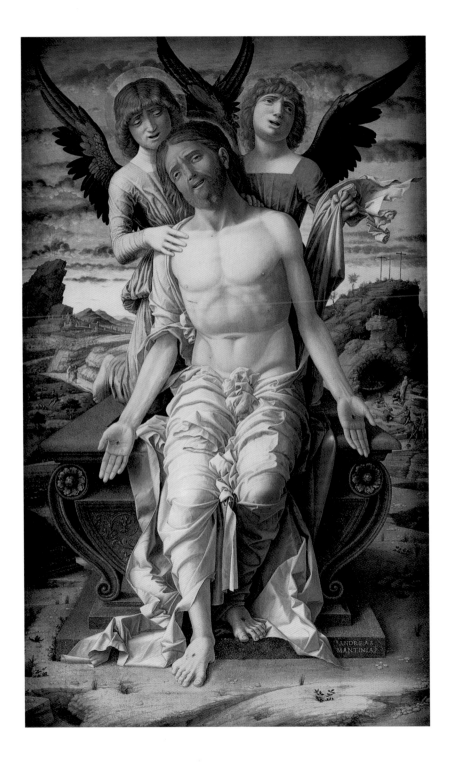

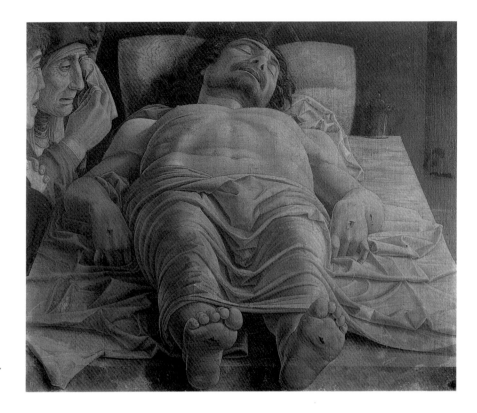

Figure 44
Andrea Mantegna.
*The Lamentation over
the Dead Christ*,
1480s. Distemper on
linen, 68 × 81 cm
(26¾ × 31⅞ in.). Milan,
Pinacoteca di Brera
(199).

tomary precision, the wounds make one wince. This painting, or a derivation of it, was listed in the inventory of Mantegna's house at the time of his death, and perhaps he used it for his personal devotions. While the dramatic foreshortening in the *Dead Christ* is virtually the opposite of the shallow relief form seen in *The Adoration of the Magi*, both were used to achieve the same end: the active participation of the viewer.

The Magi: Texts and Images

As there are only two biblical accounts of the infancy of Jesus Christ, it was natural that both would become immensely popular themes in Christian art. The Adoration of the Magi is narrated solely by the evangelist Matthew.[27] The other infancy story is Luke's chronicle of the adoration of Christ by local shepherds, which represents Jesus' recognition as the Messiah by poor and humble members of his own people, the Jews. The Adoration of the Magi, on the other hand, portrays the acknowledgment of Christ's divinity by the "Wise Men" of the Gentiles, or the whole rest of the world. For the Church, the two Adorations represent the first instances of Christian worship and therefore assume great doctrinal and liturgical importance.[28]

The Adoration of the Magi is celebrated on January 6 as the Feast of the Epiphany, one of the major festivals of the liturgical year. This event commemorates the first of Christ's revelations of his divinity to mankind, hence the term "epiphany," which literally refers to an appearance or manifestation of a divine being. Such revelations are rare in Jesus' life, so it is significant that his next two principal epiphanies are thought to have taken place on the same day of the year and therefore were celebrated along with the coming of the Magi in Mantegna's time. The Baptism, when the Holy Spirit in the form of a dove descended on Jesus from heaven at the start of his active ministry, was thought to have taken place thirty years to the day after the Adoration of the Magi. The Marriage at Cana, when Christ turned water into wine, once again revealing his divinity, was thought to have taken place the following year on January 6.

The story of *The Adoration of the Magi* is told in the second chapter of Matthew's Gospel:

> When Jesus therefore was born in Bethlehem of Judea, in the
> days of King Herod, behold, there came magi from the east to
> Jerusalem, saying "Where is he that is born King of the Jews?

For we have seen his star in the east, and are come to adore him." And King Herod hearing this, was troubled, and all Jerusalem with him. And assembling together all the chief priests and the scribes of the people, he inquired of them where Christ should be born. But they said to him: In Bethlehem of Judea. For it is written by the prophet: "And thou Bethlehem in the land of Judea art not the least among the princes of Judea: for out of thee shall come forth the captain that shall rule my people Israel." Then Herod, privately calling the magi, learned diligently of them the time of the star which appeared to them; And sending them into Bethlehem, said: "Go and diligently inquire after the Child, and when you have found him, bring me word again, that I also may come and adore him." Who having heard the king, went their way; and behold the star which they had seen in the east, went before them, until it came and stood over where the Child was. And seeing the star they rejoiced with exceeding great joy. And entering into the house, they found the Child with Mary his mother, and falling down they adored him; and opening their treasures, they offered him gifts; gold, frankincense, and myrrh. And having received an answer in sleep that they should not return to Herod, they went back another way into their country. (Matthew 2:1–12 [Douay-Rheims])

We will look more closely at the relationship between the text and Mantegna's *Adoration of the Magi* in the pages ahead. First, to fully appreciate what Mantegna has done in the Getty painting, we will consider the text itself and a brief history of its depictions.

By employing the Greek term *magos*, Matthew, writing about A.D. 60, probably meant to indicate that these witnesses to Christ's birth were members of a Persian-Anatolian priestly caste that was notably versed in astrology and the interpretation of dreams. Initially devoted to the worship of fire, the Magi had become associated with Mithraism and Zoroastrianism by the time of Christ's birth.[29] Both cults involved Christlike figures, and a Zoroastrian prophecy asserted that a star would appear to announce the virgin birth of the Messiah at the end of time. By characterizing these early witnesses to the Incarnation as foreigners learned in astronomy and religion, Matthew indicates that Christ's birth not only

fulfilled Jewish prophecy, but also that of other faiths, which now recognized the true faith.

Although Matthew does not fix the number of Magi, three are implied by the number of gifts. This was first suggested by the Greek theologian Origen in the third century, but in some early representations of the Adoration, the Magi can number as many as twelve. Nonetheless, three Magi were accepted relatively quickly as indicated by early depictions of the subject, including a panel from the famous wooden doors of Santa Sabina in Rome, carved about 430 [FIGURE 45]. Here the Magi wear Phrygian caps, with their characteristic short, conical forms pointing forward, the headgear of the priests of the Persian god Mithras.

As Mithraism and Zoroastrianism waned in the millennium following Christ, the identities of the curious "Wise Men" of the Gospel account evolved in Christian literature. By far the most important development was the identification of the Magi as kings, which was first suggested by the third-century Christian writer Tertullian, who connected Matthew's account with the Old Testament prophecy:

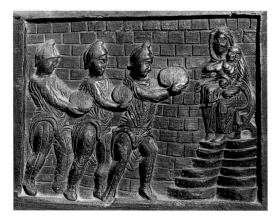

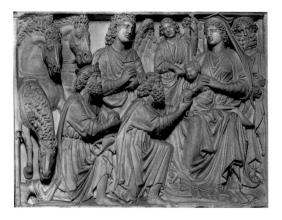

> The kings of Tharsis and the islands shall offer presents; the kings of the Arabians and of Saba shall bring gifts: And all kings of the earth shall adore him: all nations shall serve him. (Psalms 71:10–11)

The idea that this passage is an Old Testament prefiguration of the Adoration gained credence very slowly. It was not until the thirteenth century that the Magi became rather consistently depicted as kings in the visual arts, as demonstrated by the crowns in Nicola Pisano's Pisa Baptistery relief [FIGURE 46].[30]

Beyond their kingship, the Magi took on an allegorical association

Figure 45
The Adoration of the Magi, circa 430. Carved wood panel from door. Rome, Church of Santa Sabina.

Figure 46
Nicola Pisano (Italian, active circa 1258–1278, died circa 1278–1284). *The Adoration of the Magi*, 1260. Marble. Pisa, Baptistery pulpit. (Photo: Ralph Lieberman.)

Figure 47
Giotto di Bondone (Italian, circa 1267–1337).
The Adoration of the Magi, 1305–1306.
Fresco. Padua, Scrovegni Chapel. (Photo: Alinari/Art Resource, New York.)

Figure 48
The Master of the Saint Bartholomew Altarpiece (Netherlandish, active circa 1470–1510). *The Meeting of the Three Kings, with David and Isaiah*, circa 1480. Oil and gold leaf on oak, 62.8 × 71.2 cm (24 ¾ × 28 ⅛ in.). Los Angeles, J. Paul Getty Museum (96.PB.16).

that would become largely standard in their depiction. Once the three gifts of Matthew's account had determined the number of the Magi, it was only natural that they would come to represent the Three Ages of Man. Thus, in Giotto's fresco of the Adoration [FIGURE 47], painted at the beginning of the fourteenth century in the Arena Chapel in Padua, the Magi represent not only kings, but also youth, middle age, and old age. The beautiful young blond magus became a standard feature in Italian art for many years.

The development of the identities of the Magi corresponds somewhat with the growth of their cult. It was first centered in Milan, where the relics venerated as the bones of the Magi were kept until 1164. Then Emperor Frederick Barbarossa had them transferred to Cologne, where they still rest in the sumptuous shrine begun by Nicholas of Verdun in 1181. The German emperors fully recognized the political importance of possessing the relics of the first kings to adore Christ and receive his blessing. It became traditional that after coronation in nearby Aachen, the emperors would come to receive "confirmation" at the shrine of the Magi. Thus, Cologne became the undisputed center of the magian devotion and their identification as kings was set.[31]

An important factor in the growth of the cult of the Magi was a literary work—the *History of the Three Kings* by John of Hildesheim—that collected information from every imaginable source, so that ideas from church fathers coexist with fanciful popular beliefs. Composed between 1364 and 1375,[32] the book brought the Magi to life in tales of adventure, prompting the expansion of their cult as well as the creation of new visual imagery.

We can see this in a work of about 1480 by a Cologne painter [FIGURE 48] that depicts one of the imagined climactic moments in the tale, the rendezvous of the kings at Golgotha, the very hill where Christ would later be crucified

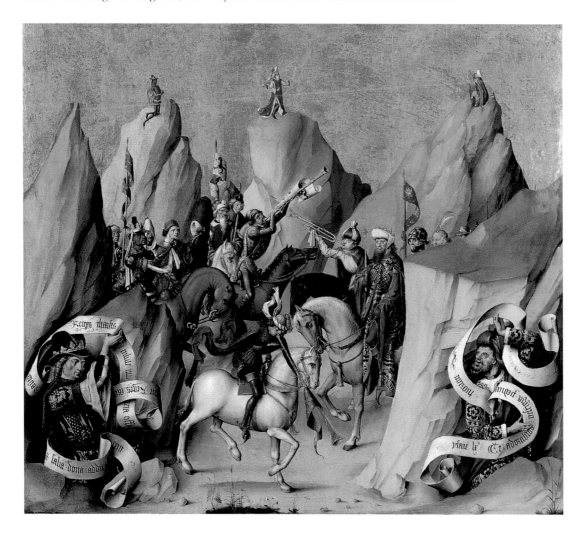

to save the souls of the faithful. Thus, the barren spot where the Christian mission was fulfilled serves as the meeting place for those foreigners who would first recognize that the baby Jesus was the Messiah. In the foreground, giant figures of prophets hold banderoles with Old Testament prefigurements of the coming of the Magi; at left, King David brandishes the text of Psalm 71: "The kings of Tharsis and the islands shall offer presents"; at right, Isaiah bears a banner reading "All they that despised thee shall bow themselves down at the soles of thy feet" (Isaiah 60:14). As trumpeters herald the event, we note that each magus wears a crown and that each entourage is identified by a different standard.

Figure 49
The Master of the Saint Bartholomew Altarpiece. *The Meeting of the Three Kings, with David and Isaiah* [detail].

FROM THE CORNERS OF THE EARTH

The very subject of *The Meeting of the Three Kings* calls attention to the idea that they did not travel together to find Jesus. The biblical text states only that they came from the East, which early Christian writers logically assumed to mean Arabia or Persia. However, by the fifth century, this literal reading had been given an allegorical twist by Christian scholars. Rather than representing just one nation or cult, the Magi came to represent all non-Jewish people of the world. As Pope Leo the Great (r. 440–461) pronounced in a sermon, "In the three magi, all peoples adore the author of the universe."[33]

At the top of *The Meeting* each of the Magi is depicted on a separate peak gazing toward the star, indicated by punchwork in the gold ground (now quite worn). In the scene below, the kings arrive from three different directions and, while two of them are depicted with fair skin, the youngest is black [FIGURE 49]. The notion that one of the Magi might be dark skinned had existed for some years, but Hildesheim definitely declared, without elaboration, that one of the Magi was a "black Ethiopian."

At the time, Europeans had little knowledge of Africans in their native land, but artists did not have to look far for models. Outbreaks of bubonic

plague, the infamous Black Death, had greatly depleted the population of Europe in the fourteenth and fifteenth centuries. This led to a tremendous need for cheap labor, which slave traders were only too happy to provide.

Although Africans constituted only a part of this human commodity, by the early fifteenth century the flow of black slaves had increased dramatically. Driven by greed, Europeans were beginning to realize the extent of Africa and its people. If the Magi symbolized all the people of the world, then it was becoming clearer in Mantegna's age that a black person might rightly be included among them.

Many distinct factors influenced the creation and acceptance of the black magus, first in Northern Europe and only much later in Italy.[34] Perhaps most important were stories, quite prevalent throughout Europe by the fifteenth century, of a holy black leader of a distant people. It was thought that the Emperor of Ethiopia was the legendary Prester John, the pious ruler of a far-off Christian empire who entered the European consciousness during the Crusades.[35] The term Prester John may once have been the name of an individual, but it came to be used as a kind of title for the hereditary ruler. As Christians were becoming aware of the power and extent of Islam, Prester John was conscripted into the role of the ally from afar who would handle the eastern front in the holy war. The legend contended that he was not only a black king but also the ordained leader of his church, and furthermore, that he was the descendant of one of the Magi who had worshiped the baby Jesus. In the art of Germany and the Netherlands, the black magus rapidly became the standard, but the rest of Europe was not so quick to follow.

THE MAGI IN ITALIAN ART

Even though the cult of the Magi in Italy was somewhat undermined when their relics were spirited away in 1164, depictions of the Adoration were nonetheless popular.[36] While the subject of the Magi always lent itself to the introduction of the exotic, their identification as kings opened the possibility of introducing pomp and grandeur in their depiction. The development of grandiose imagery in depictions of the Adoration reached its zenith along with the courtly International Gothic

style in the fifteenth century. This was particularly true in Florence, where a series of Magi paintings attest to the city's continuing devotion to their cult. As John the Baptist is the patron saint of Florence and Christ's Baptism was celebrated on the same day as the Adoration, the Magi took on special significance there.

The trend toward epic, courtly treatments of the theme is perhaps best exemplified by Gentile da Fabriano's altarpiece of 1423 [FIGURE 50], commissioned by the fabulously wealthy Palla Strozzi for the sacristy of the Church of Santa Trinita.[37] Here, the arts of painting, gilding, and framemaking are brought to bear to create the impression of utmost sumptuousness.

The entourage of the Magi has grown and explodes into the foreground as the Wise Men realize the object of their journey. Their progress to this moment can be followed in a continuous narrative in the background, where three separate episodes in their travels appear in each of the arches across the top of the painting. At left, the three gaze together at the star from atop a mountain peak while ships await in the ocean below to whisk them away; in the center arch, they make their entrance into Jerusalem; and at right, they arrive in Bethlehem. Although each scene is distinct in place and time, Gentile beautifully unifies the road so that the eye undulates from scene to scene and then moves into the foreground as though having traveled a seamless path from start to finish.

This dazzling production demonstrates the more typical treatment of the theme since the late Middle Ages, albeit at its most spectacular. The Wise Men have become kings, and they are followed by an incredibly elaborate and extensive retinue. No other subject was quite so exploited by painters to dazzle the eye, as it provided a suitably pious context for the display of exotic sumptuousness in a pageant of richly costumed figures and animals. Here, the panels sparkle with an extravagant use of gold. Gentile also indulged the opportunity to present a wealth of human detail, as in the page removing the spur of the young blond king and the midwives behind the Holy Family examining the first gift. Generally, the crowd is distracted as the sacred moment unfolds. The profusion of natural detail, from the landscape to the rendering of the attendants, is used to create a vitality and an exuberance that expresses the joyous realization of a goal: witnessing the birth of the Savior.

The procession of the Magi became a subject on its own in Florence, most notably in 1459, when Piero de' Medici commissioned Benozzo Gozzoli to

Figure 50
Gentile da Fabriano (Italian, circa 1370–1427). *The Adoration of the Magi*, 1423. Tempera and gold on wood, 300 × 282 cm (118 × 111 in.). Florence, Galleria degli Uffizi (8364). (Photo: Arte Video/Fontana, Florence.)

paint a continuous fresco around the walls of his chapel [FIGURE 51]. Here, amid the spectacle, portraits figure prominently, probably reflecting the elaborate pageants staged to celebrate the Epiphany by a lay confraternity called the Company of the Magi, which included many prominent Florentines. These celebrations included a spectacular procession through the city to various stages where the action was played out, and contemporary descriptions convey that they were every bit as sumptuous and bright as Gozzoli's fresco.[38] Playing the role of attendants to the three kings, the marchers emphasize that they follow the Magi in worshiping the Christ Child.

MANTEGNA'S FIRST *ADORATION OF THE MAGI*

Shortly after arriving in Mantua in 1460, Mantegna created his first known version of *The Adoration of the Magi* [FIGURE 52] for Lodovico Gonzaga. We know that he treated the subject again in 1490 in a private chapel for the pope in the

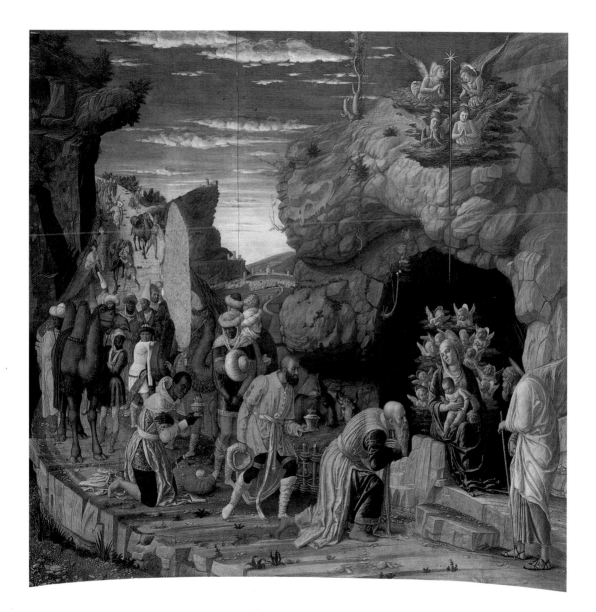

Vatican, but this fresco was destroyed in the eighteenth century, making the Uffizi *Adoration* Mantegna's only other extant rendition of this theme. Among Christian rulers, the subject was a favorite, not only to serve as a righteous example but because the patron by association could declare his or her pious acceptance of God's higher authority. Mantegna's early *Adoration* served as the centerpiece of the cycle of paintings for his master's new chapel in the Castello. The panel itself is concave, running contrary to the sweep of the road. Apparently designed to fit into a niche above the altar of the small chapel, it is yet another brilliant optical tour de force as Mantegna asserts that he can manipulate any surface to achieve his illusion.

As he was preparing this work to impress his new master, Mantegna seemingly turned again to his father-in-law's example for inspiration with the composition. Jacopo Bellini had worked in Gentile da Fabriano's shop and was quite familiar with his master's sweeping composition in the Strozzi altarpiece, as is evident in a series of drawings from his sketchbooks. In two of these, the artist's preference for expansive views results in the subject being dwarfed. The most focused example [FIGURE 53] demonstrates not only knowledge of Gentile's composition, but Bellini's mastery of perspective and love of nature.

Bellini's drawing probably served as Mantegna's starting point, but his narrative skills stand out in spite of the similarities. In the Uffizi *Adoration* he has his road sweep down so that the main action—the climax of the long

journey—is laid out directly before the viewer, now using the whole foreground. The road also allows the artist to display the Magi's exotic train back into the distance, but without disturbing the narrative focus of the main scene. Of all his smaller paintings, this is the most densely packed; but how modest and practical the train seems in comparison with most representations.

REPRESENTING THE CONTINENTS

While *The Meeting* [FIGURE 48] shows one black and two white Magi, Mantegna clearly distinguishes three races in his *Adoration* [FIGURE 52], reflecting the idea that they personify the three continents of the then-known world: Europe, Asia, and Africa. An early printed map [FIGURE 54], perhaps produced in Venice, shows the basic knowledge of world geography in the years before the 1488 voyage of Bartolomeu Dias around the Cape of Good Hope, which brought a better comprehension of the extent and form of Africa.[39] The three continents, surrounded by ocean on a flat planisphere, are boldly marked. While Europe is well charted, it is apparent that the cartographer's knowledge of more remote areas in Asia and Africa was sketchy at best.

Figure 54
Circular World Map,
1485–1490. Venice (?).
Copper engraving,
DIAM: 17.3 cm (6 ⅞ in.).
Vienna, Österreichische
Akademie der Wissen-
schaften, Sammlung
Woldan.

63

In the late fifteenth century, even at the great crossroads of Venice, people would have associated Asia principally with the area we know as the Middle East. Not only was there an ancient tradition of maritime commerce in the eastern Mediterranean, but Venice's culture was closely tied with Byzantium. Contact with East Asians was still very limited, although that would change slowly in the early sixteenth century. Thus, in Mantegna's painting, the middle magus is given Semitic features.

Mantegna's painting contains one of the earliest examples of an African magus in Italian art, and the motif would not gain acceptance until well into the sixteenth century. Blacks had long been included as attendants in depictions of the Adoration, but always serving three white Magi. Certainly, Mantegna's own experience of Africans was probably confined to servants at the Gonzaga court, where they had long been valued for their exotic qualities. Pisanello included a dark-skinned male youth in one of his frescoes in the Palazzo Ducale before 1442, and it will be remembered that Mantegna features a black maid through the oculus at the apex of the Camera Picta [FIGURE 29].

How then did Mantegna come to use a black magus? While it is possible that he knew John of Hildesheim had characterized Caspar as black, the German treatise had remarkably little influence in Italy. Very few copies were available, and it was never translated into Italian.[40] Likewise, Mantegna might have known pictorial examples from Germany, but it is not impossible that the black magus was created in Italy independent of the German tradition. After all, as soon as the three Magi became the kings of the three continents, the depiction of an African was made imperative. Likewise, the legend of Prester John was widespread and invited confirmation in modern depictions of his legendary ancestor, the black magus.

MANTEGNA'S EPIPHANY

In Mantegna's first version of the Adoration of the Magi [FIGURE 52], each element in the composition is brought to bear to communicate the theme of the Epiphany. He places the Madonna and Child in the mouth of a dark cave because light filling darkness was one of the principal metaphors of the coming

of the Messiah in the Judeo-Christian tradition. Mantegna sets his narrative in the light of dawn to celebrate the Epiphany and the birth of Christian worship. With the star gleaming directly above, and in the company of the angelic host, the Magi begin to kneel in turn as stooped Joseph looks on. Melchior, the first and oldest magus, has already presented his gift. He folds his arms across his chest in rapture as he receives his blessing. Balthasar, balancing his gift but gazing intently at the baby, has just stepped up behind Melchior and is about to kneel. Behind the others, Caspar has fallen to his knees, overcome, as if afraid to approach, yet proffering his gift. Together, they present a stately image of worship. In the background their retinue projects exoticism with costumes such as dervish hats, turbans and hoods, and props, including a quiver of Islamic design. The camels are accurately rendered, possibly because Mantegna knew a real example from a prince's menagerie. Here the artist indulges in presenting the variety and strangeness of the world; but the picturesque is always subordinate to the main theme.

As this painting was created for the Gonzaga's chapel, it is tempting to speculate that the Getty *Adoration* was also painted for their use. Three to four decades later, a new kind of Adoration was perhaps required in another palace, or possibly for their living quarters, or even a small oratory intended for private prayer. Owing to Mantegna's role as a court artist, it is certain that the painting was executed with the approval of the Gonzaga, if not on their direct orders. We might speculate that they wanted the painting for one of their relations, friends, or political associates, or perhaps someone named after one of the Magi; but no likely candidates have been found.[41] If the original owner was one of the Gonzaga or their princely relatives, then Mantegna's painting would stand as the prime example of appropriate behavior before God: paying homage to the true source of their earthly power.

The Compositional Innovation

The close-up treatment of the Getty *Adoration of the Magi* is its most distinctive aspect, setting it apart from virtually all prior representations, including Mantegna's own earlier version of the subject. Indeed, this type of half-length narrative scene, reduced to essentials and viewed up close, was perhaps Mantegna's greatest invention in devotional painting.

It seems so natural as to not deserve comment, but Mantegna was the first to use the half-length format for a narrative scene. In about 1455, he created *The Presentation in the Temple* [FIGURE 55], wherein Mary and Joseph have brought the infant Jesus to the Temple of Jerusalem to be "consecrated to the Lord" according to the law for firstborn sons (Luke 2:22–39). The devout priest Simeon takes Jesus from his mother for the ceremony. Simeon had been promised that he would not die until he had seen the Messiah, and when he recognizes the Child, he proclaims "Lord, now lettest thou thy servant depart in peace." At the moment when Jesus is consecrated to the Lord in the ceremony for firstborn males, Mantegna alludes to his special purpose on earth: his sacrificial death at the end of his ministry. The artist achieves this by tightly wrapping the swaddling clothes in the manner of a shroud and by giving the baby an ethereal, woeful expression. Likewise, the Virgin's somber visage tells that she has recognized the significance of the ceremony and the road her son would soon take. In the background, two figures, perhaps donors, are distracted by things outside the image, emphasizing that we are privy to the private realizations of Simeon and Mary.[42]

Mantegna was capable of creating a splendid re-creation of the Temple of Jerusalem, as he did several years later in *The Circumcision* (Florence, Galleria degli Uffizi). Why then in *The Presentation* did he not indulge his passion for formulating convincing and beautiful architectural settings with brilliant juxtapositions of rich stone? Why did he turn to the use of the close-up?

In the search for new, compelling ways of involving the faithful in visual meditation, Mantegna and other ground-breaking artists in the last half of the fifteenth century diversified the traditional repertory, both in the choice of subjects and in the form they would take.[43] As we have seen, one major trend in devotional art involved the extraction of holy figures from narrative contexts, often setting them against a dark background. This includes such popular images as Christ Carrying the Cross, which depicts him isolated from the soldiers and crowd usually present in representations of the Procession to Calvary. Likewise, the Pietà, in which the sorrowful Virgin cradles the dead Christ in her lap, was distilled from representations of the Lamentation at the foot of the cross. In both, the elimination of subsidiary characters and setting was intended to intensify focus on the suffering of the holy figures and encourage the viewer's empathetic involvement.[44]

In Mantegna's *Presentation* and *Adoration of the Magi*, biblical narrative scenes are depicted in the half-length format against a dark ground more often seen in the iconic images common in devotional art. Painters of such pictures had long recognized that the half-length composition, originally developed for portraiture, has the distinctive quality of making the viewer feel close to the represented persons. Mantegna perhaps realized that this close-up format could be exploited with certain narratives to create new, more elaborate devotional pictures. These representations are neither full narrative histories nor iconic or "cultic" images in serene isolation where narrative plays no role.

In one sense, Mantegna's two compositions may have resulted from nothing more than a desire for variety in depicting the Madonna and Child or the Holy Family. However, Mantegna also understood Alberti's concept of narrative as potentially revealing a multiplicity of meanings, and perhaps he wanted to exploit biblical subjects, especially stories well known to the faithful, to encourage a variety of meditational paths. Such scenes offered not only more characters to involve the mind of the viewer, but also the interaction between the players, as well as the meaning of the action itself, for contemplative absorption.

In *The Presentation*, Mantegna uses a window motif to enhance the viewer's sense of spatial proximity to the scene. Long before the Camera Picta, he uses painted architecture to create a formal boundary between our space and that of the picture so he can immediately pretend that there is no barrier

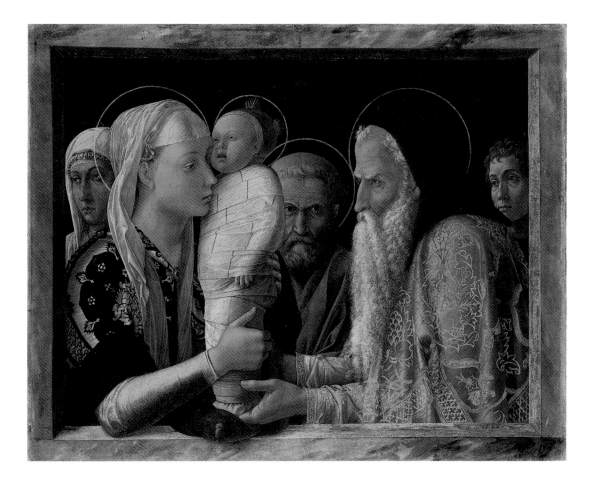

Figure 55
Andrea Mantegna.
*The Presentation
in the Temple*, circa
1455. Distemper on
linen, 68.9 × 86.3 cm
(27⅛ × 33⅞ in.).
Berlin, Staatliche
Museen, Preussischer
Kulturbesitz, Gemälde-
galerie (29). (Photo:
Jörg P. Anders.)

Figure 56
Andrea Mantegna.
Saint Mark, circa 1448.
Distemper(?) and gold
on canvas, 82 × 63.7
cm (32¼ × 25 in.).
Frankfurt, Städelsches
Kunstinstitut. (Photo
© Ursula Edelmann.)

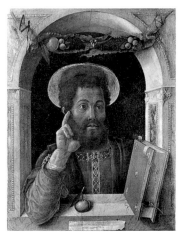

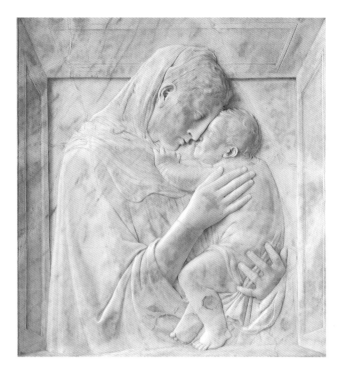

between them. The marble frame gives the eye a point of reference and the pillow the Christ Child stands on seems to project across the picture plane and into our space.

Figure 57

Donatello. *The Pazzi Madonna*, 1420s. Marble, 74.5 × 69.5 cm (29⅜ × 27⅜ in.). Berlin, Staatliche Museen, Preussischer Kulturbesitz, Skulpturengalerie (51). (Photo: Jörg P. Anders.)

A WINDOW TO THE WORLD OF THE BIBLE

The window motif had fascinated Mantegna since his early years, when he set Saint Mark in an archway [FIGURE 56], no doubt to heighten the sense of his real presence. While Mantegna was familiar with many uses of architecture as a bridge between art and reality, the simple window frame of *The Presentation* may have been suggested to him by Donatello, whose *Pazzi Madonna* [FIGURE 57] illustrates it at its most dramatic and effective.[45] Here, the grave, interlocking profiles are set within a frame that creates an atmosphere of detachment and dignity for the figures while simultaneously evoking a sense of spatial proximity for the viewer. These are the formal aspects that attracted Mantegna to use the motif.

It is also possible that Mantegna employed the window motif in *The Presentation* as a metaphor for the boundary between the new and old orders, between Church and Synagogue. At this marble opening in the temple wall, the Son of God is consecrated to his service by the representative of the priesthood that would be supplanted by his ministry. The Virgin alone leans directly upon the frame, suggesting her classic identification as the *fenestra coeli*, the window to heaven, "through which God shed true light on the world."

Not surprisingly, Mantegna's leap of the imagination in extending the half-length relief to a multi-figure composition was also conditioned by the art of antiquity—perhaps even the same source that inspired Donatello.

THE EXAMPLE OF ROMAN ART

The basic format of both *The Presentation* and *The Adoration of the Magi* was perhaps suggested to Mantegna by a form of ancient relief sculpture that would have been well known to him. While Mantegna turned to ancient narrative reliefs again and again because no ancient history paintings were known, in this case, he was perhaps inspired by a type of portraiture. Busts appear in such an oblong format with some frequency in Roman funerary reliefs [FIGURE 58], which existed in large numbers in north Italy.[46] Couples are most often depicted, but whole families enclosed in boxes were also known. Usually, the busts are disposed only frontally, but the best examples have a down-to-earth immediacy and naturalism that perhaps tickled Mantegna's imagination in his quest to outdo antiquity, for the bust-length ancient relief was never used for narrative.

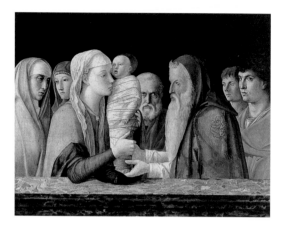
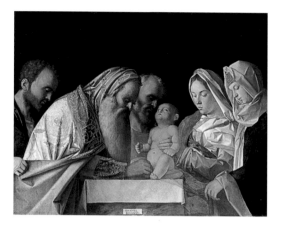

THE CRITICAL FORTUNE OF MANTEGNA'S INVENTION

Not long after Mantegna first employed the half-length format for his narration of the Presentation in the Temple, the composition was taken up by his brother-in-law, Giovanni Bellini [FIGURE 59], who copied the core composition but inserted yet another pair of figures into the background.[47] Bellini also turns the window into a parapet, a motif his father, Jacopo, had imported from Florence and that the son used to great effect throughout his career. In the otherwise virtually identical compositions, it is remarkable how much Mantegna's intensity and gravity of expression are softened by Giovanni, illustrating his far sweeter artistic personality.

Mantegna's invention of the half-length narrative was to have greater influence in the Bellini workshop than in his own oeuvre. Extending the usage to another logical infancy narrative, Bellini himself may well have created a prototype of *The Circumcision*, known today only in workshop versions [FIGURE 60]. Here, the plan of Mantegna's work is still exerting a powerful influence, and in both we note the inclusion of donors as witnesses or attendants. There are many variations on each of these compositions—some with donors filling the scene, some set in landscapes—but never again demonstrating the focus of Mantegna.

The Adoration of the Magi in the Getty Museum happens to be one of Mantegna's most influential compositions. While direct copies exist, they tend to be rather rudimentary and uninteresting.[48] However, Mantegna's composition was quickly appropriated by other artists, who began to add their own personal

Figure 59
Giovanni Bellini (Italian, circa 1430/40–1516). *The Presentation in the Temple* (after Mantegna), 1455–1460. Tempera on wood, 80 × 105 cm (31½ × 41⁵⁄₁₆ in.). Venice, Galleria Querini-Stampalia.

Figure 60
Workshop of Giovanni Bellini. *The Circumcision*, circa 1500. Oil on wood, 74.9 × 102.2 cm (29½ × 40¼ in.). London, National Gallery (1455).

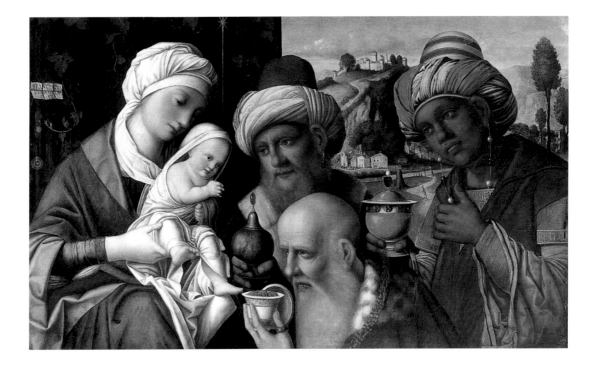

Figure 61
Francesco da Santa
Croce (Italian, circa
1440–1508). *The
Adoration of the Magi*
(after Mantegna), circa
1500. Oil on wood,
62 × 100 cm (24 ⅜ ×
39 ⅜ in.). Formerly
Berlin, Kaiser Friedrich
Museum (22), destroyed.

Figure 62
Titian (Tiziano Vecellio)
(Italian, circa 1485–
1576). *The Tribute
Money*, circa 1516.
Oil on wood, 75 ×
56 cm (29 ½ × 22 in.).
Dresden, Staatliche
Gemäldegalerie.

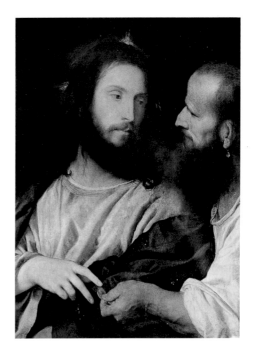

touches. Probably the earliest, a free copy by Francesco da Santa Croce [FIGURE 61], is also quite close to the original, but it eliminates the figure of Joseph. Rather than using this deletion to make the composition more compact, the artist spreads the figures out, dissipating the intimacy of the scene and necessitating a gesture for the black magus that is awkward at best. Santa Croce's insertion of the star and addition of the landscape demonstrate clearly why Mantegna chose to eliminate them: they distract from the main action. Finally, Francesco's powers of expression are no match for Andrea's, as the banal expressions tell. Santa Croce's composition was the source for many others, some clearly from his shop, which were customized at random.[49] While Mantegna's invention enjoyed a brief vogue, this was apparently due mainly to the ease of inserting portraits as attendants of the Magi. In general, Mantegna's works were little copied because his concentration and technique defied easy reproduction or enlightened incorporation into the work of others.

The half-length format was to enjoy some popularity among artists of the sixteenth century for paintings of the Madonna and Child with saints or

Figure 63
Caravaggio (Michelangelo Merisi da Caravaggio) (Italian, 1573–1610). *The Doubting of Thomas*, circa 1602. Oil on canvas, 107 × 146 cm (42⅛ × 57½ in.). Potsdam, Sanssouci, Stiftung Schlösser und Gärten (GK I 5438). (Photo: Christoph Schmidt.)

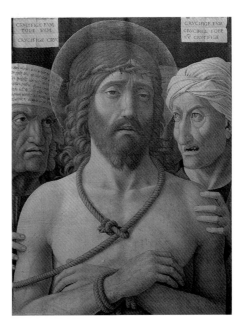

donors, but it was never employed with frequency for narrative scenes. It was used a bit more commonly for one- or two-figure devotional narratives, such as Titian's *Tribute Money* [FIGURE 62] of about 1516, perhaps the truest half-length narrative in the Mantegnesque sense of the sixteenth century.[50] After that, it was almost a century before another revolutionary artist, Caravaggio, would combine the close-up format with unflinching naturalism to examine the moment when Christ proves to Thomas that he has risen from the dead [FIGURE 63].

MANTEGNA'S TREATMENT OF THE PASSION IN DEVOTIONAL PAINTINGS

Other than in the Getty *Adoration*, Mantegna never used the close-up form again with an infancy narrative. However, he did use it for the other principal focus of Christian devotion: the Passion of Christ. Mantegna's drive to produce devotional paintings with innovative narrative elements to engage the viewer is perhaps best illustrated with one of his most haunting works, the *Ecce Homo* in Paris [FIGURE 64], which we have already seen owing to its extraordinary state of preservation.

"Ecce Homo" (Behold the man!) are the words spoken by the Roman governor Pilate when he presented Christ to the Jewish people to determine his fate (John 19:4–7). When depicted as a full narrative illustration of the biblical text, Pilate is usually shown mockingly gesturing toward the "King of the Jews" at his side on a balcony or a stage, while the throng watches from a distance. Mantegna returns to the biblical text, but does not produce a pure, descriptive narrative. The suffering Christ is surrounded not by the Roman guards who have just tortured him, but rather by frightening enemies among his own people, who grasp him with their hands. The pseudo-Hebrew on the headdresses suggests that these people are the high priests and their followers who called for Jesus' crucifixion. Here, Mantegna uses the effect of spatial proximity with chilling results.

The brilliant juxtaposition of their hatred and contempt with Jesus' transcendent sorrow becomes a terse, direct expression of the essence of the Ecce Homo narrative: Christ's acceptance of his fate at the hands of unbelieving members of his own people. Unusually, Mantegna incorporates the actual words of the Bible on little slips of creased paper. These bear the searing demands of the people: "Crucify him, take him and crucify him." After a while the viewer notes the eerie figures lurking in the background, as if forming a circle around Christ. The deep effect this work has on a meditative viewer comes as he or she reads the words over and over, and is ultimately drawn into the composition to complete the circle. As Christian doctrine holds that Christ's suffering and death were made necessary by sin, so the faithful viewer who has sinned is drawn into the scene and must identify with the grotesque crowd, facing his or her guilt in the suffering of Christ as the words resonate in the mind. While penitential meditation was the aim of all devotional paintings of Passion subjects, there is nothing remotely like Mantegna's abstraction of the biblical narrative for its inclusive narrative focus.

The devotional painter's goal of empathetic involvement was essentially the same as the painter of *historia* and, while Alberti did not necessarily have religious subjects in mind, his methods were applicable, especially in Mantegna's hands.

Now we can at last return to *The Adoration of the Magi* with some understanding of the compositional device in the context of Mantegna's oeuvre and the devotional practices of his time.

Reading *The Adoration of the Magi*

Mantegna and the Biblical Text

As with most depictions of the Adoration of the Magi, Mantegna's painting shows the climactic moment in the story, which Matthew narrates with these few words:

> And entering into the house, they found the Child with Mary his mother, and falling down they adored him; and opening their treasures, they offered him gifts: gold, frankincense, and myrrh. (Matthew 2:11)

Mantegna's posing of a limited number of figures against a dark ground is virtually as terse as Matthew's text in its own idiom. While the painting is faithful to the style of the Gospel story, Mantegna augments the basic account with some elements of the Magi legend and a few innovations of his own.

Executed forty to fifty years after *The Presentation* [FIGURE 55], *The Adoration of the Magi* [FIGURE 1] demonstrates Mantegna's growth as a painter. The static, slightly stiff quality of the action in *The Presentation* is now gone. While the subsidiary figures in *The Presentation* played no active role in the narrative, in *The Adoration of the Magi*, the composition is focused and clear. The darkness leaves the setting to the imagination; it signifies that they have come inside, whether the interior of a "house" or the cave preferred in many pictures. Most significantly, the figures are now larger, promoting an even greater sense of physical proximity to the viewer. By this time in his career, Mantegna deemed the window frame an impediment.

That Mantegna did not rigidly adhere to the Gospel is most apparent in his addition of Joseph [FIGURE 65]. Nonetheless, we know that Joseph had brought his family to Bethlehem, his hometown, for the census called by Augustus. Thus, he is almost required by the context to be the earthly protector of the Holy Family. Indeed, here he scrutinizes the exotic strangers with a mixture of

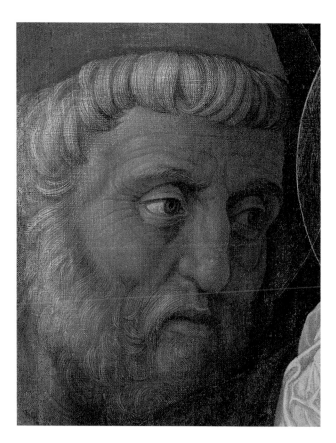

Figure 65
Andrea Mantegna.
The Adoration of the Magi
[detail].

curiosity and suspicion. In contrast to the Virgin's contemplative humility, Joseph is the image of the active, probing side of human existence.

Mantegna creates a Madonna of simple but exquisite beauty [FIGURE 66], her head and eyes cast downward to stress her humility. A hint of remoteness is preserved from more iconic images, as well as a faintly Byzantine canon of beauty, especially in her almond-shaped eyes. While her bodice is trimmed with pseudo-Hebrew script, Mantegna is historically accurate in showing it without buttons, as garments in Mary's day were commonly laced on [SEE FOLDOUT].

Mantegna's characterization of the Magi in the Getty *Adoration* resembles his earlier rendition of the theme [FIGURE 52]. Once again, they are depicted in their allegorical capacities as the Three Ages of Man and the Three Continents, but these allusions are now emphasized owing to the close-up view.

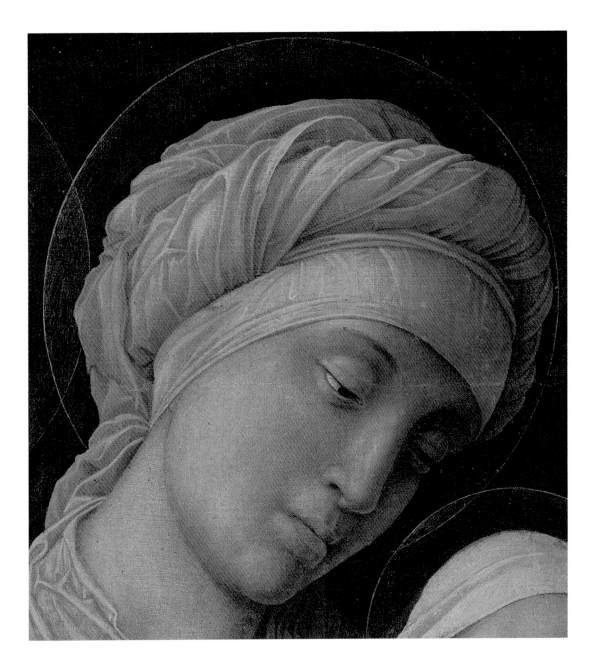

Figure 66
Andrea Mantegna.
The Adoration of the Magi
[detail].

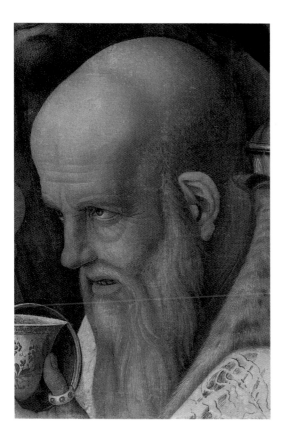

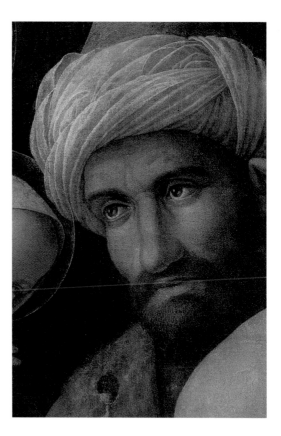

Melchior [FIGURE 67], the oldest, represents Europe, and kneels first, presenting his offering of gold. On his pale complexion, age lines are incised like those on a Roman Republican portrait. His ear is bent back from having just removed his headdress, a motif that must reflect an actual consequence of wearing a turban, since it appears again and again in Mantegna's oeuvre. Melchior's respectful uncovering of his head reveals a large cranium appropriate to one so wise. Bald and bearded, he is the image of a sage.

Balthasar [FIGURE 68], representing middle age and Asia, stands behind Melchior with his gift of frankincense. As in the Uffizi *Adoration* [FIGURE 52], Mantegna gives the Asian magus the ruddy pigmentation and dark beard of a Semitic man, even though tradition—at least for the intended audience— prevents the application of the same racial characteristics, however historically accurate, to the baby Jesus and his mother.

Figure 67
Andrea Mantegna.
The Adoration of the Magi
[detail].

Figure 68
Andrea Mantegna.
The Adoration of the Magi
[detail].

79

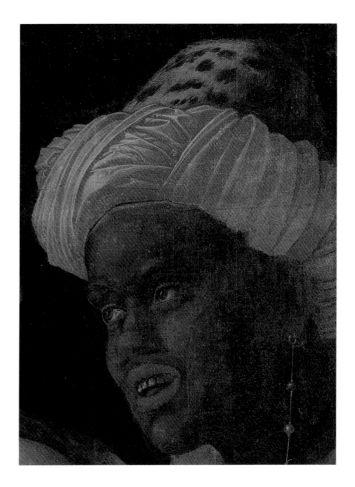

Figure 69
Andrea Mantegna.
The Adoration of the Magi
[detail].

And finally, Caspar [FIGURE 69], representing youth and Africa, holds up his gift of myrrh. Not many Italian painters had adopted the black magus in the thirty to forty years since Mantegna included him in his earliest rendition of the subject. In Italy, his appearance in this work, executed toward the turn of the century, would still have been a curiosity and a cause for meditation on its significance in the Magi theme.

Isabella d'Este, who joined the Gonzaga court in 1490, sustained a keen interest in Africa, no doubt engendered by personal contact with her servants.[51] This kind of burgeoning curiosity about other races and cultures, combined with the fantasy of Prester John, the priest-king of Ethiopia and supposed descendant of a magus, must have made the characterization of a magus as black

seem all the more appropriate to conveying the universality of the Christian mission in the atmosphere of the court at Mantua.

Just as the black page had been dandified in paintings, Mantegna felt the greatest freedom regarding the attributes of the African. While Melchior's thumb ring was not unusual in Mantegna's Europe, the earring-necklace worn by the black magus is apparently a complete fabrication as no such jewelry form is known from any culture. Beautifully formed and polished translucent gemstones are mixed with pearls on a gold thread, complete with miniature knots. This type of bejeweled chain was also used by Mantegna about this time for Pegasus's harness in the *Parnassus* (Paris, Musée du Louvre), completed in 1497.

As advanced as Mantegna's personification of the Three Continents in *The Adoration* might have seemed, it was outdated almost as soon as it was created, for as the artist was working on the painting, Columbus was making his voyages to America.

THE GIFTS

We have not called attention to the gifts of the Magi in discussing prior treatments of the theme because in these works they feature as little more than elements of the pomp. In such a concentrated composition, however, they take on a greater significance. In the most basic sense, gold, frankincense, and myrrh represent costly and rare presents, but the gifts came to be interpreted symbolically as well.[52] Gold, the most precious of metals, was interpreted as paying homage to Christ's kingship. Frankincense, a gum resin from a tree native to east Africa and Arabia, had been specified by God for use in incense for divine service (Exodus 30:34–38); here it pays homage to Christ's divinity or honors his priesthood. Myrrh, another east African and Middle Eastern gum resin, was used in embalming Christ's body (John 19:39–40), and Christian scholars since the second century agree in interpreting the gift as foreseeing the death and burial of the Son of Man.[53]

The vessels Mantegna provides to hold the gifts are as rich and exotic as their contents. Usually these objects are depicted in similar, richly jeweled golden jars and caskets, often mimicking reliquaries and eucharistic vessels, as in Mantegna's earlier rendition of the Magi theme [FIGURE 52]. But in the Getty

painting, the artist clearly differentiates each object by shape and material, perhaps to underscore the distinct origins of the Magi. More likely, he wanted to impress upon us that these were special presents because no attempt is made to create vessels indigenous to each continent. (Remember that in *The Triumphs of Caesar* [FIGURE 31] Mantegna did not hesitate to sacrifice historical accuracy to effect.)

We only see the substance of the gift being presented, the one first mentioned in Matthew's Gospel: gold [FIGURE 70]. Melchior lifts the lid of the cup to show that it is nearly filled with gold coins of varying sizes and types. The container was far more rare and mysterious. Mantegna's painting is well known to students of Asian ceramics as one of the earliest representations of Chinese blue-and-white porcelain in European art. A trickle of examples had filtered into Europe in the fifteenth century, sometimes as gifts sent to the doges of Venice and other prominent persons from the sultans of Cairo.[54] The Gonzaga also collected porcelain when they could, perhaps providing Mantegna with a model for the form and decoration.

Among surviving examples of real porcelain, Mantegna's vessel most closely resembles the form of a *yashou bei*, or wine cup [FIGURE 71], made in the contemporary Ming dynasty.[55] If this type of vessel was Mantegna's model, then he greatly enlarged and elongated the traditional form and added a lid. How-

ever, owing to its breakable nature, porcelain from this early period is quite rare, even in Chinese collections. Thus, the possibility cannot be completely excluded that Mantegna based his vessel on an actual soup or tea cup with a lid, whether from the Gonzaga collection or known to him from Venetian sojourns. According to experts in the field, the decoration on Mantegna's cup might represent a contemporary Chinese pattern. [56]

Porcelain was particularly valued because the chemical composition was not understood, in spite of efforts by European potters to duplicate it. This mystery resulted in the popular belief that porcelain was not entirely fabricated by the hands of man.[57] The dazzling white surface, incredible thinness, and exquisite translucency of porcelain must have seemed like a foreign substance to people of Mantegna's time, something beyond the capacity of mere mortals to manufacture or fully comprehend, and thus an appropriate present for a divine king.

The other two gifts are no less sumptuous, even if they are not as exotic. For these, Mantegna indulged his passion for semiprecious stone. Perhaps, like the porcelain, Mantegna's vessels were based on real examples no longer known, for such rare and beautiful objects were avidly collected by Isabella d'Este for the decoration of her apartments.

Balthasar presents the frankincense in a rich container made of an orange-red stone with veins, possibly a form of jasper, although losses of paint in this area make it difficult to identify. The vessel, which may allude to the shape of a censer or incense carrier, is topped by a bell-shaped silver cap with a finial of a translucent gemstone.

Caspar waits behind to present the myrrh in a covered jar composed of agate or chalcedony, beautifully turned. Interestingly, recent attempts to identify the types of stone in Mantegna's paintings have concluded that the artist never seems to imitate real stone, but rather bases his creations so closely on nature that they seem quite real.[58] Perhaps Mantegna chose a rich stone urn to hold the myrrh for the anointment of Christ's body because elegant stone was preferred for the remains of a king; see, for instance, the sarcophagus in *The Man of Sorrows* [FIGURE 43].

As in Mantegna's earlier rendition of the Adoration of the Magi for Lodovico Gonzaga [FIGURE 52], the artist does not stress the Magi's kingship. But while there are no crowns, the rich furs and jewels might imply that they

are rulers. Was Mantegna perhaps accommodating the wishes of the marquis of Mantua, ruler but not king?

<p style="text-align:center">THE IMAGE OF CHRISTIAN WORSHIP</p>

As we have noted, the Adoration of the Magi represents one of the earliest revelations of Jesus' identity as the Son of God, and one of the first instances of Christian worship. The basic composition reflects the form of a presentation to a ruler or priest, with the object of worship on one side facing an adoring group approaching from the other. Mary's showing of the Child reflects not only the proud mother before special visitors, but also her traditional symbolic role as the personification of *Ecclesia*, the Church itself, the mother of all the faithful.[59] In making this identification, Church Fathers related that just as Mary's womb held Christ, so the Church embraces his spirit on earth, and just as the Virgin presented him to the Magi, so the Church presents his true image to the world. Thus, her gesture evokes a ritual action, much as a priest would display a sacred object or the consecrated host to the public.

The Christ Child responds to the worship of the Magi with the bestowal of a childlike blessing [FIGURE 72]. The blessing gesture had long been a traditional motif in the depiction of the Christ Child. It was most often seen in representations of the Madonna and Child, where the benediction can be directed at the viewer, at a saint or kneeling supplicant, or at the Magi. Mantegna had already employed it in his earlier version of this theme [FIGURE 52], where he gives the infant the ability to bless with his arm raised in the formal priestly gesture. In the Getty painting, Mantegna makes it clear that the Child is blessing by isolating his index and middle fingers, but in an inspired example of the artist's naturalism in symbolic representation, the gesture is turned into the jerking movement of an infant. In Mantegna's hands, the gesture of the Christ Child itself becomes a sign of the Incarnation because, just as Jesus the man would have to die, here the divine Child is limited to blessing as a human infant might.

Mantegna's treatment of the Christ Child's drapery has not been commented on, and yet the child's blanket has great significance for this painting. The swaddling clothes mentioned in one account of the nativity (Luke 2:7) have several functions here beyond serving as the simple garment of a newborn.

As we have seen, the swaddling clothes also traditionally allude to the shroud that would wrap Christ's body in death, announcing the end of his earthly life virtually as soon as he is born. Usually, the swaddling clothes took the form of a mummy wrap, as in Mantegna's *Presentation in the Temple* [FIGURE 55] or the Berlin *Madonna and Child* [FIGURE 38], but our artist used more loosely fitting "shrouds" as well [FIGURES 37 and 39]. Mantegna had also depicted the infant Christ in a contemporary child's dress, with short tunic and broad sash, as in his earlier *Adoration of the Magi* [FIGURE 52].[60]

If we examine the Child's drapery in the Getty *Adoration*, it becomes evident that Mantegna wrapped the cloth as if it were a toga, slung around his left shoulder and held over his left arm in the classic manner. The left arm of the baby is held up to make this clear. Of course, the toga was in use at the time of Christ's birth, but only for adult men.[61] The key to its significance in this context is in the particular way it is wrapped, because the Christ Child is depicted *togatus capite velato*, or in a toga with his head covered. Mantegna certainly knew that a Roman male would only be shown in this way to designate that he was a priest acting in a ritual role. The artist was probably acquainted with this motif principally from images of the emperor in his role as Pontifex Maximus, the high priest. During his stay in Rome, Mantegna likely visited the Church of Santa Martina in the Roman Forum to see the great Aurelian reliefs then housed there, one of which shows Marcus Aurelius sacrificing at the Capital [FIGURE 73].[62] Churchmen of the time would have found no fault in this application of a pagan form to the Christ Child because they would have understood that the ancient Roman title of Pontifex Maximus, with both its priestly and kingly connotations, had been inherited by the pope in his role as Christ's vicar on earth. As Christ was ultimately the high priest of his Church, this use of the *togatus capite velato* form was eminently apposite for the ritual context of this painting, complete with gesture of blessing. Mantegna's genius lies in large part in the thoroughly unobtrusive way that the toga motif is applied.

The appropriateness of depicting Christ *togatus capite velato* in this context may have been Mantegna's idea, but one of his close friends in Mantua, Battista Fiera (circa 1465–1538), dabbled in costume history in addition to his roles as physician and poet at the Gonzaga court.[63] In 1499, perhaps as Mantegna was working on the painting, Fiera was serving as the costume advisor in Isabella

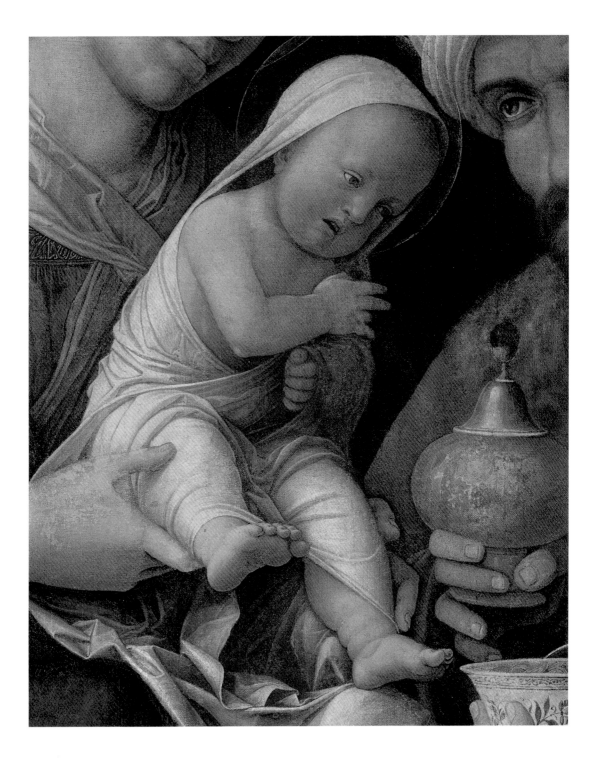

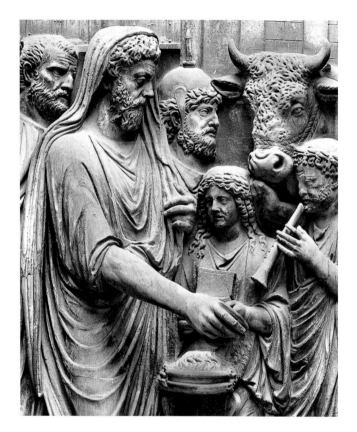

Figure 72
Andrea Mantegna.
The Adoration of the Magi
[detail].

Figure 73
Marcus Aurelius
Sacrificing Before the
Capitoline Temple
[detail of Figure 28:
Marcus Aurelius
as Pontifix Maximus].

d'Este's project to raise a monument to Mantua's most famous son, the poet Virgil.[64] Thus, Fiera might have introduced Mantegna to the finer points of toga usage and history.

The Adoration of the Magi fulfills its role as an image of worship. Here, the faithful are given the benefit of worship: the blessing of Christ. Finally, we must consider the effect of worship on the Magi and on the viewer.

THE APPEAL TO THE EMOTIONS

In evaluating the purpose of images, learned ecclesiastics of the era recognized that feelings of devotion are aroused more effectively by things seen rather than by things heard.[65] In *The Adoration of the Magi*, every turn of the head, every glance of the eyes, every nuance of gesture is studied for optimum impact. Mantegna deliberately abandons any use of perspective or any form of setting. Landscape, one of his most evocative tools in the creation of *historia,* is put aside. Even the star, so crucial to the narrative, is eschewed. In *The Adoration of the Magi*, Mantegna blocks out all else to concentrate on the psychologies of the principal characters in the scene.

One of Alberti's basic tenets for the effective conveyance of *historia* involved using the expression of emotion to lead the viewer to the main point:

> A *historia* will move spectators when the men painted in the picture outwardly demonstrate their own feelings as clearly as possible. Nature provides—and there is nothing to be found more rapacious of her like than she—that we mourn with the mourners, laugh with those who laugh, and grieve with the grief-stricken. Yet these feelings are known from movements of the body.[66]

In an Adoration, the Magi served as clear role models for the faithful, establishing the appropriate devotional state for emulation—that is, if they were not lost amid exotic pageantry.

In Mantegna's composition, the Magi are clearly differentiated by states of awe. These faces believe they behold the incarnation of God. At right, Caspar is lost in ecstatic wonder, his mouth agape. Balthasar in the center is

neither fearful nor exuberant, but mesmerized by the experience. The elderly Melchior presents his gift with his head bowed, not allowing his eyes to meet those of the Child, in a kind of fearful respect that one gives an encounter outside the realm of usual experience, and perhaps reflecting age-old fears of looking directly at God.

In this close-up view, Mantegna's vivid characterizations of the psychological reactions of the Magi serve to draw the viewer into appropriate action: worship of the Christ Child, and meditation on his Incarnation and its purpose for personal salvation. There are few subjects in the life of Christ that so directly offer sacred characters to serve this role for the faithful.

In order to give some idea of the desired effect, it might be instructive to read a short passage from a popular devotional tract that emphasized personal meditation based on the Gospel story. In this instance, it provides insight into possible thought processes employed by the faithful when meditating on the Adoration.

In treating the Adoration of the Magi, the author states: "I intend to recount a few meditations according to imagined representations, which the soul can comprehend differently, according to how they happened and how they can be credible in a holy manner." In these, the author asks the reader to step into the story, to look closely at the characters, and to kneel with the three kings and experience the events while he or she meditates:

> The Magi . . . knelt impulsively before the Boy, adoring Jesus reverently, honoring Him as King and worshiping Him as God. You see how great was their faith, which asked them to believe that this Child, so scantily clothed and found with His poor mother in so wretched a place, with no attendants or family, and lacking all furnishings, was King and true God. And yet they believed both. These kings remained kneeling before Him, conversing with the Lady, for they were very wise and perhaps knew the Hebrew tongue. They asked her about the condition of this Child and believed everything the Lady related. Regard them well as they reverently speak and listen; and see also the Lady as, with great modesty in speech, her eyes always turned to the ground, she finds no pleasure in speaking much or in

being seen. . . . Behold also the Child Jesus, who does not speak as yet, but watches them benignly, with maturity and gravity, as though He understood them; and they delighted in Him, instructed by inward vision and illuminated, for he was beautiful above all the children of men. Finally, having received great comfort, they offered gold, incense, and myrrh . . . and with reverence and devotion they kissed His feet. Perhaps at this the judicious Child gave them His hand to kiss and blessed them to give greater solace and to fortify them in their love for Him.[67]

There is no evidence that Mantegna ever sought to illustrate such written meditations, but the similar intent of both writer and painter here is striking. Naturally, the written meditation and the painted image depend on the biblical text, but it is interesting to note the degree to which both appeal to the imagination of their audience. Of course, Mantegna's painting places the spectator alongside the Magi and visualizes a great deal for us. The Virgin Mary even proffers the foot of the Christ Child for kissing. The format of the painting, its simplicity, its being staged against a dark ground were all surely meant to achieve an end similar to that of the devotional literature: to allow the mind to enter into a worshipful state in a personal way, to allow the imagination freedom to become involved in the narrative.

Ultimately, the viewer is drawn to the force at the center of the composition, the one whole form in the half-length format: the baby with his hand raised in blessing. Here, Mantegna concentrates his powers of invention to find visual equivalents for the Incarnation in his favorite sources, classical antiquity and nature. There could be no better reconciliation of Roman pagan culture and Christianity in this context than Mantegna's application of the *togatus capite velato* to the Christ Child's swaddling clothes. And no better use of naturalism in the service of higher meaning than the conflation of the gesture of blessing with the jerking movement of a human infant.

The message of *The Adoration of the Magi* is that faith is rewarded with the ultimate blessing of Christ: salvation from death itself. The explicit depiction of different races sends the clear signal that salvation is not restricted to one nation or people. Likewise, salvation is not aimed at only the old or the young, but people of all ages. Finally, in Mantegna's composition the Magi do

not kneel together. Rather, the two behind are appropriately awed, but wait for their turns to appear before Jesus. The overwhelming message here is that the individual is important. The individual is the one who is saved. And for Mantegna, the individual is the viewer.

In a way, *The Adoration of the Magi* is the culmination of Mantegna's efforts toward creating personalized devotional images. These works are personalized not by depicting a donor, but by including the spectator. In *The Funeral of the Virgin* [FIGURE 24], we saw that Mantegna chose a view well known to his patrons in order to enhance the sense of actuality. In *The Man of Sorrows* [FIGURE 43], the artist opened the eyes of the dead Christ to look directly at the viewer and elicit his or her sympathy. In the *Ecce Homo* [FIGURE 64], the use of text along with powerful imagery brings the faithful meditator into the ring around Jesus. Finally, in the *Dead Christ* [FIGURE 44], mourning figures lead the viewer to the appropriate response. At some point, the artist must have realized that the Adoration of the Magi provided the perfect context for involving the spectator in the world of the Bible; the original worshipers could show the way in contemporary devotion to the Child Messiah.

Through the close-up composition, the frank expressiveness of the figures, and the visual symbols gleaned from nature and antiquity, Mantegna conveys the essential meaning of this religous *historia*: Jesus is revealed as God and man, king and high priest. The Magi not only lead the viewer to worship and wonder, but also to receive the blessing given by God Incarnate in recognition of their faith. Thus, *The Adoration of the Magi* bacomes an original contribution to devotional imagery, a composition that challenges the intellect and the heart toward meditative involvement with the theme.

In its clear differentiation of characters and its self-conscious inclusion of the viewer, Mantegna's painting evokes a new Renaissance conception of the importance of the individual. Today, some five hundred years after the painting was made (and in spite of the ravages of time), the image continues to fascinate viewers, whether Christian or not. While the precision and beauty of Mantegna's style accounts for much of this, it is ultimately the artist's deep sincerity and keen humanity that will ensure the enduring power of this painting for generations to come.

NOTES

1 For the following discussion of Mantegna's technique, I am greatly indebted to Andrea Rothe, who thoroughly researched and restored *The Adoration of the Magi* between 1985 and 1988. Fundamental to the topic is his ground-breaking study, "Mantegna's Paintings in Distemper," in Jane Mantineau et al., *Andrea Mantegna*, exh. cat. (London, Royal Academy of Arts, and New York, Metropolitan Museum of Art, 1992), pp. 80–88. For a broader consideration of Mantegna's working methods, see Keith Christiansen, "Some Observations on Mantegna's Painting Techniques," ibid., pp. 68–78; and Jill Dunkerton, "Mantegna's Techniques," in *Mantegna and Fifteenth-Century Court Culture*, Francis Ames-Lewis and Anka Bednarek, eds. (London, 1993), pp. 26–38.

2 The *Ecce Homo* is by far the best preserved. Sadly, only three other distemper paintings by the artist have not been varnished: the *Madonna and Child* (Bergamo, Accademia Carrara) [FIGURE 39], the *Lamentation over the Dead Christ* (Milan, Pinacoteca di Brera) [FIGURE 44], and the *Judith with the Head of Holofernes* (Dublin, National Gallery of Ireland) [FIGURE 30]. The profound effect of varnish is quite dramatically illustrated by the juxtaposition of Mantegna's three distemper paintings of the Madonna and Child [FIGURES 37–39], where only one [FIGURE 39] has survived unvarnished.

3 Visitors to the Getty Museum can walk to a gallery near Mantegna's *Adoration* and see a well-preserved distemper painting, *The Annunciation* of about 1450 by Dieric Bouts (85.PA.24), whose surface will demonstrate the beautiful, unified effect of the medium. Even though it

must be viewed behind glass and in lower light so that its colors will be preserved, the wonderful luminosity of distemper is nonetheless evident. This type of painting was more widely practiced in Northern Europe (see Diane Wolfthal, *The Beginnings of Netherlandish Canvas Painting: 1400–1530* [Cambridge, 1989]). Mantegna may well have been inspired by the refined uses of distemper in works like this that had made their way to Italy. Bouts's painting was rediscovered in Milan in the nineteenth century, and many more examples were almost certainly at hand in Mantegna's time. However, unlike Mantegna, Bouts did not apply a ground to his linen, so the fabric's texture is more discernible and less like the surface texture of fresco.

4 Charles Yriarte, *Mantegna* (Paris, 1901), pp. 211–212.

5 For a survey of critical opinions on this painting, see Keith Christiansen's entry on it in *Andrea Mantegna* (note 1), p. 237, no. 56.

6 See Caroline Elam in David Chambers and Jane Martineau, eds., *Splendours of the Gonzaga*, exh. cat. (London, Victoria and Albert Museum, 1981), p. 122, n. 32.

7 On the monument, see Anthony F. Radcliffe in *Andrea Mantegna* (note 1), p. 90.

8 The earliest known life of Mantegna was published in 1550 by Giorgio Vasari in the first edition of his *Lives*, which he revised and enlarged for the edition of 1568. The subsequent bibliography on Mantegna is vast. The reader should start with the catalogue for the exhibition at the Royal Academy and the Metropolitan Museum of Art, *Andrea Mantegna* (note 1), which will provide key references to prior bibliography.

9 On Donatello, see especially John Pope-Hennessy, *Donatello: Sculptor* (New York, London, and Paris, 1993). On early Mantegna and Donatello, see Martha Levine Dunkelman, "Donatello's Influence on Mantegna's Early Narrative Scenes," *Art Bulletin* 62 (1980), pp. 226–235.

10 On Jacopo Bellini, see Colin Eisler, *The Genius of Jacopo Bellini: The Complete Paintings and Drawings* (New York, 1989).

11 On the Gonzaga, see especially David Chambers and Jane Martineau, *Splendours of the Gonzaga* (note 6) and *Mantova e i Gonzaga nella civiltà del Rinascimento: Atti del Convegno . . .* (Mantua, 1977).

12 On Pisanello at the court of the Gonzaga, see Joanna Woods-Marsden, *The Gonzaga of Mantua and Pisanello's Arthurian Frescoes* (Princeton, 1988). On the artist's *Saint Eustace*, see Christopher Baker and Tom Henry, *The National Gallery: Complete Illustrated Catalogue* (London, 1955), p. 532.

13 On Alberti's architecture, see the handy compilation by Franco Borsi, *Leon Battista Alberti: The Complete Works* (New York, 1989). On Alberti and the culture of his time, see Joseph Rykwert and Ann Engel, eds., *Leon Battista Alberti*, exh. cat. (Mantua, Palazzo Te, 1994). On Sant'Andrea, see E. J. Johnson, S. *Andrea in Mantua: The Building History* (University Park, Pennsylvania, 1975).

14 Anthony Radcliffe, "Antico and the Mantuan Bronze," in *Splendours of the Gonzaga* (note 6), pp. 46–49, as well as the pertinent catalogue entries, pp. 132–140, nos. 49–61. On Antico generally and the Getty bronze in particular, see Ann Hersey Allison, "The Bronzes of Pier Jacopo Alari-Bonacolsi, called Antico," *Jahruch der Kunsthistorischen Sammlungen in Wien* (1993), pp. 62, 257–260.

15 Leon Battista Alberti, *On Painting and On Sculpture: The Latin Texts of De Pic-tura and De Statua*, translated and edited by Cecil Grayson (London and New York, 1972). On the relationship between Mantegna and Alberti, see Michelangelo Muraro, "Mantegna e Alberti," *Atti del VI Covegno internazionale di studi sul Rinascimento* (Florence, 1996), pp. 103–132. On Mantegna's relationship to *On Painting*, see especially Michael Baxandall, *Giotto and the Orators* (Oxford, 1971), p. 133 and Jack M. Greenstein, *Mantegna and Painting as Historical Narrative* (Chicago and London, 1992).

16 Neither version of Alberti's treatise was published until the middle of the following century, so Mantegna must have known it from a manuscript copy.

17 Prof. Greenstein (note 15), chapters 1–3, comprehensively underscores the many layers of significance of this term in the Renaissance. A broad overview of the meaning of *historia* in Alberti's work is given by Grayson in his introduction to Alberti (note 15).

18 The top of this painting has been removed and a fragment, now in the Pinacoteca Nazionale, Ferrara, shows that originally Christ was shown receiving a tiny effigy representing the Virgin's soul at the apex of the composition; see *Andrea Mantegna* (note 1), pp. 159–160, n. 16.

19 See Baxandall (note 15), chapter 3.

20 On the Camera Picta, see Randolph Starn and Loren Partridge, *Arts of Power: Three Halls of State in Italy, 1300–1600* (Berkeley, Los Angeles, and Oxford, 1992), part 2, including prior bibliography. The popular name for the room, *Camera degli Sposi*, referring to the marquis and his consort, was first used in the seventeenth century and came into widespread use only later.

21 On the *Triumphs*, see Andrew Martindale, *The Triumphs of Caesar by Andrea Mantegna in the Collection of H. M. the Queen at Hampton Court* (London, 1979) and Charels Hope in *Andrea Mantegna* (note 1), pp. 350–372. The paintings were begun

after 1484 and may have been finished as early as 1492, but it is likely that the commission was amplified and that the middle group of three canvases, including this one, were not finished until his last years. This was quite plausibly argued by Hope, ibid., p. 351.

22 Jaroslav Pelikan, *Jesus Through the Centuries: His Place in the History of Culture* (New Haven and London, 1985), chapters 11–12, presents an eloquent interpretation of this historical change.

23 For a survey of devotional trends and art of this period, although with a bias toward Northern Europe, see Henk van Os et al., *The Art of Devotion in the Late Middle Ages in Europe, 1300–1500*, exh. cat. (Amsterdam, Rijksmuseum, 1994–95).

24 John Pope-Hennessy, "The Madonna Reliefs of Donatello," *Apollo* (March, 1976), pp. 172–191.

25 See Alistair Smith, *Andrea Mantegna and Giovanni Bellini*, Themes and Painters in the National Gallery, no. 12 (London, 1975).

26 See, for instance, Thomas à Kempis, *The Imitation of Christ* (London and New York, 1910), a work still popular in Mantegna's time.

27 On the biblical texts, their interpretation and significance, see Raymond E. Brown, S.S., *The Birth of the Messiah: A Commentary on the Infancy Narratives in Matthew and Luke* (London, 1977).

28 On the general theme of the Adoration of the Magi, Hugo Kehrer, *Die heiligen drei Könige in Literatur und Kunst*, 2 vols. (Leipzig, 1908–9) has not been superseded.

29 Joseph Bidez and Franz Cumont, *Les mages hellénisés: Zoroastre, Ostanès et Hystaspe d'apres la tradition grecque* (Paris, 1938), vol. 1, p. 51, and Kehrer (note 28), vol. 1, p. 22, and G. Messina, *I Magi a Betlemme e una profezia di Zoroastro* (Rome, 1933).

30 Kehrer (note 28), vol. 1, pp. 64–76, and vol. 2, pp. 225–27.

31 Hans Hofmann, *Die heiligen drei Könige; Zur Heiligenverehrung im kirchlichen, gesellschaftlichen und politischen Leben des Mittelalters*, Rheinisches Archiv, 94 (Bonn, 1975).

32 Johannes von Hildesheim, *Die Legende von den Heiligen Drei Königen* (Munich and Cologne, 1963).

33 Paul H.D. Kaplan, *The Rise of the Black Magus in Western Art*, Studies in the Fine Arts: Iconography, No. 9 (Ann Arbor, 1985), p. 22.

34 Kaplan, cited in the preceding note, is an exemplary and thorough study of the black magus in art. It is eminently readable for those interested in pursuing this fascinating topic in depth.

35 E. Denison Ross, "Prester John and the Empire of Ethiopia," in *Travel and Travellers of the Middle Ages*, Arthur Percival Newton, ed. (New York, 1926), pp. 175–194, and Charles E. Nowell, "The Historical Prester John," *Speculum* 28 (1953), pp. 435–445.

36 Gert Duwe, *Die Anbetung der Heiligen Drei Könige in der italienischen Kunst des Trecento und Quattrocento* (Frankfurt, 1992).

37 Keith Christiansen, *Gentile da Fabriano* (Ithaca, 1982), pp. 23–37, 96–97, no. 9.

38 On the Florentine tradition, see Rab Hatfield, *Botticelli's Uffizi "Adoration": A Study in Pictorial Content*, Princeton Essays on the Arts, 2 (Princeton, 1976).

39 Tony Campbell, "The Wieder-Woldan Incunable World Map," *Imago Mundi* 42 (1990), p. 83.

40 Kaplan (note 33), p. 114.

41 Melchior, the prominent European magus in the foreground, would seem the most likely candidate, but his unusual name cannot be connected with a contemporary

figure. The same is true of the name
Caspar in Italy at this time, but Baltassare
was a known name, although no logical
candidates have emerged.

42 It has been suggested that these two
 "donors" represent Mantegna and his wife,
 Nicolosia Bellini, although Mantegna
 seems somewhat younger than in the ear-
 lier Ovetari fresco. For this interpretation,
 see Wolfgang Prinz in *Berliner-Museen* 12
 (1962), pp. 50–54.

43 Sixten Ringbom, *Icon to Narrative: The
 Rise of the Dramatic Close-up in
 Fifteenth-Century Devotional Painting*,
 2 rev. ed. (Doornspijk, 1984) has been the
 fundamental source on this development
 since his study was first published in 1965.

44 See, particularly, F. O. Büttner, *Imitatio
 Pietatis: Motive der christlichen Ikonogra-
 phie als Modelle zur Verähnlichung*
 (Berlin, 1983).

45 On the window motif generally, see Carla
 Gottlieb, *The Window in Art* (New York,
 1981). On the Pazzi Madonna, see Pope-
 Hennessy, *Donatello: Sculptor* (note 9),
 pp. 254–256.

46 Hermann Pflug, *Römische Porträtstelen
 in Oberitalien: Untersuchungen zur
 Chronologie, Typologie und Ikonographie*
 (Mainz, 1989).

47 On the identification of the donors as
 Bellini's own family, see Dazzi and
 Merkel, *Catalogo della Pinacoteca della
 Fondazione Querini Stampalia* (1979),
 pp. 34–35, no. 3.

48 See, for instance, the one in the Johnson
 Collection at the Philadelphia Museum
 of Art.

49 New versions of this composition turn up
 with some frequency. See the recently
 published, fine example, presumably from
 Santa Croce's shop, formerly in the de
 Marinis collection in Florence; see Gio-
 vanni Agosti, "Su Mantegna, 5 (Intorno a
 Vasari)," *Prospettiva*, no. 80 (October
 1995), p. 63, fig. 5. Agosti lists other exam-

ples on p. 83, note 29, to supplement
those outlined by Ronald Lightbown
(Oxford, 1986), pp. 445–446, no. 43. In
my opinion, the Getty canvas need not
have been in Venice to spawn the numer-
ous copies made there, but only one of
the copies. Also, Santa Croce's composi-
tion is clearly the basis for many of these
paintings, not Mantegna's.

50 A few years before, about 1511, Titian
 had tried his hand at a more complex,
 multi-figure, half-length narrative
 in the *Christ and the Adulteress* (Vienna,
 Kunsthistorisches Museum), but left
 it unfinished in spite of having developed
 a composition of great promise.

51 For instance, in 1491 her brother Alfonso
 dispatched a detailed account, which he
 knew would interest her, of a European
 group's visit to a West African island,
 complete with drawings of the people and
 their land. Paul H. D. Kaplan, "Isabella
 d'Este and the Representation of Black
 Africans," paper delivered at the College
 Art Association Annual Conference,
 Chicago, 1992.

52 A text once attributed to the Venerable
 Bede (circa 673–735), but composed
 by an Irish or Anglo-Saxon contemporary,
 was most probably the source for the
 western, allegorical interpretation of the
 gifts. See Robert E. McNally, "The Three
 Holy Kings in Early Irish Latin Writing,"
 in *Kyriakon: Festschrift for Johannes Quas-
 ten*, Patrick Granfield and Josef A. Jung-
 mann, eds. (Münster, 1970), pp. 669–
 670. For a fascinating eastern interpreta-
 tion of the gifts, as reported by Marco
 Polo, see Leonardo Olschki, "The Wise
 Men of the East in Oriental Traditions,"
 in *Semitic and Oriental Studies*, Univer-
 sity of California Publications in Semitic
 Philology, v. 11 (Berkeley, 1951), pp.
 375–381.

53 See Kehrer (note 28), vol. 1, pp. 12–13, 31,
 and 48. Nigel Groom, *Frankincense and
 Myrrh: A Study of the Arabian Spice Trade*
 (London and New York, 1981), presents

an engaging account of the uses and trade of these spices in the ancient world.

54 A. I. Spriggs, "Oriental Porcelain in Western Paintings, 1450–1700," *Transactions of the Oriental Ceramic Society* 36 (1964–66), p. 74. Not surprisingly, the three earliest examples of porcelain depicted in European paintings are all from northeast Italy. The other examples are the *Madonna and Child* attributed to Francesco Benaglio (Washington, National Gallery of Art), datable to the 1460s, and Giovanni Bellini's *Feast of the Gods* (Washington, D.C., National Gallery of Art), dated 1514.

55 Only four *yashou bei* of this type are known: three in the Peking Palace Museum and this one from a private collection, sold at Sotheby's, London, June 10, 1986, lot 220. On the two in Peking that match this one, see J. M. Addis, *Chinese Ceramics from Datable Tombs* (London and New York, 1978), pp. 82–84. They bear the mark of the emperor Yongle and were manufactured between 1420 and the emperor's death in 1424.

56 See, for instance, Spriggs (note 54), p. 74. The pattern on Mantegna's vessel does not correspond to any extant example and may well be Mantegna's abstract mimicking of the lotus-flower motif seen in more characteristic form on the real *yashou bei*.

57 See Donald F. Lach, *Asia in the Making of Europe* (Chicago and London, 1970), v. 2, pp. 104–109.

58 Roger Jones, "Mantegna and Materials," *I Tatti Studies: Essays in the Renaissance*, 2 (1987), pp. 71–90.

59 For the Virgin as the personification of the Church, see, for example, Henri de Lubac, *Splendor of the Church* (Glen Rock, N.J., 1963), chap. 9.

60 Mantegna also depicted the infant Christ in contemporary child's dress in *The Infant Redeemer* (Washington, D.C.,

National Gallery of Art 1146); see Christiansen in *Andrea Mantegna* (note 1), 147, no. 15. See him use the same short tunic with wide cummerbund on children in *Saint James Baptizing Hermogenes* [FIGURE 12], and in *The Circumcision* (Florence, Galleria degli Uffizi).

61 Lillian M. Wilson, *The Roman Toga*, Johns Hopkins University Studies in Archaeology, no. 1 (Baltimore, 1924).

62 The foreground arms of the figures and the legs of the tripod were missing when Mantegna was in Rome. It was moved to the Campidoglio by Leo X in 1515 and was restored only in 1595. See Phyllis Pray Bober and Ruth Rubinstein, *Renaissance Artists and Antique Sculpture* (London, 1986), no. 191, pp. 223–224, on the relief and its copies in the Renaissance. The church was replaced in the seventeenth century by Pietro da Cortona's Church of Santa Martina e Luca.

63 On Fiera, see E. Faccioli, *Mantova: Le lettere* (Mantua, 1962), v. 2, pp. 366–73, *Splendours of the Gonzaga*, p. 154, and *Andrea Mantegna*, exh. cat. (London and New York, 1992), pp. 20–24, 27.

64 Ibid., p. 23.

65 Michael Baxandall, *Painting and Experience in Fifteenth-Century Italy* (Oxford and New York, 1972), pp. 40–41, provides a translation of a sermon by the Dominican Fra Michele da Carcano published in 1492 that considers the orthodox view of the function of images.

66 Alberti (note 15), p. 81 (Alberti, *De Pictura* 2:41).

67 Isa Ragusa and Rosalie B. Green, *Meditations on the Life of Christ* (Princeton, 1961), pp. 50–51. The tract was written about 1300 by a Franciscan for a nun of the Poor Clares, but in Mantegna's time it was attributed to Saint Bonaventure himself and still enjoyed great popularity.